THE PRINCIPLES OF GOOD
TASTE AND ORNAMENT

THE PRINCIPLES OF GOOD TASTE AND ORNAMENT

JADA HENRY

NEW DEGREE PRESS

COPYRIGHT © 2020 JADA HENRY

THE PRINCIPLES OF GOOD TASTE AND ORNAMENT

ISBN

978-1-64137-935-9 *Paperback*

978-1-64137-734-8 *Kindle Ebook*

978-1-64137-735-5 *Digital Ebook*

CONTENTS

FROM ME TO YOU

—

Somebody nobody knows is somebody we all know.

Those who we experience, whether they pass us on the street, sit next to us on the metro, cut us off on the freeway, hand us our order at the city bakery, teach our younger sibling's third-grade class, stands on the corner of Main Street reminding us how much God loves his children, or whatever scenario fits your fancy, are symptomatic to accumulated actions and ideals.

Like water is essential to life for a fish, largely unnoticed and under-appreciated in most circumstances, in the world there is the woman.

A woman is meant to bear children across cultures beyond near and far lands. She is meant to care for all around her. She is meant to be second. She is meant to be dutiful, poised, and ever obeying.

Within the fine print of duty, it is untold that women must become subservient to the emotional and psychological weight of such a gendered role. Anything outside that specifically curated ideal is a danger, an abomination, a perversion to man and his world.

This weight is undoubtedly the catalyst to trauma; a non-linear experience when it is observed through the frame of

identity ... undoubtedly, it can make one's self-awareness murky. Without ownership of oneself, what is left of an identity or self-purpose?

The delirium that comes along with trauma affects not one but *all* as it becomes a virus that absorbs sense of self, sense of worth, or sense at all.

We so often rely heavily on women in this world without giving them credit or truth to who they are. We objectify, we vilify. Yes, *we*, even you and I, subconsciously perpetuate harmful ideals that aren't fair to women, which in turn is not fair to us all. If we use and abuse those who bear their souls, who are we as people? Who are we as humans? A million silhouettes have become of the lost individuality within female identity.

In this story of systemic and social betrayal, the epicenter of the nuclear family hides behind the perpetuation of roles that define women "for better or for worse." Once the root of a tree is poisoned, death will find its way into the limbs, leaves, and trunk. To save it, the elixir of equity is what is desired, which understanding, diligence, and healing will bring to centuries of oppression.

No, it won't be easy, but it is worth the effort. Welcome self-awareness before delusion welcomes you. And dear God, please do not attempt what Ann would do.

ACKNOWLEDGEMENTS

———

In the creation of this book, I never imagined the kind of dedication and behind the scenes collaboration it would have taken to make such a story come alive. I am very happy to have reached the finish line in my book journey. I've discovered along my journey writing *The Principles of Good Taste and Ornament* that publishing a book takes a village, and I am so grateful for all the support. Fulfilling this dream would not have been possible without you.

Thank you first and foremost to my family for supporting me every step of the way, always.

Special thanks to Kristy Carter, Michael Bailey, Jennifer Candiotti, Jamie T, Brian Bies, Gina Champagne and Eric Koester.

Thank you to everyone who gave me their time for a personal interview, pre-ordered the eBook, paperback, and multiple copies to make publishing possible, helped spread the word about *The Principles of Good Taste and Ornament* to gather amazing momentum, and helped me publish a book I am proud of. I am sincerely grateful for all your help.

Pamela Henry
Christopher Henry
Kristie Abraham*
Eric Koester
Lavender Williams
Laquilla Jones
Barbara Ann Friedman
Jonathan Danziger
Ashley Seidel
Nancy Rousseau
Lara Emily Spotts
Lucia Burns
Annita Hornsby
Haley Newlin
Yvonne Williams

Paula Scott
Winnfer Scott
Alani Weeks
Carolyn Townsend
Harriet Lambert
Margie Thrower
LaWanda Porter
Julian Williams
Aurélie Trac
Carla D. Droughn
Victoria Carranza
Rosiland Williams
Joseph Lee
Nona Whittaker

1

THE MOORES

Soon we'll be done with winter's run
then spring will come to have some fun
Although lost lives paid a cost
A new leaf turns as all is gone with winter's frost
Time and time wanes again
but new beginnings we can depend
Winter, winter please go away
Please, spring, please, spring come out to play

"Are you ready for your red ribbon week speech?" asked Drew to her brother Elliot. She was sat in the backseat of their parents' car neatly dressed in her dark blue button-up and tan skirt uniform opposite her bewildered younger brother as he peered out the car window.

"I guess so," he said, never moving his gaze away from the window. He fashioned a maroon button-down and tan slacks, the required uniform for first- through fifth-grade students.

"So then let's hear it," Drew bluntly said. Elliot's eyes cut sharply to his sister without his body moving an inch. He peered at her untied Chuck Taylors before reverting his glance

toward the car window, which was the only thing separating him from the outside world beyond the car.

"It's not ladylike to manhandle the conversation, sweetheart," their dad said. "Let your brother decide for himself."

Elliot's mouth curved as he was not sure if the agency he was being given was just another sly scheme to get him to do something he would rather not do.

"...No, I remember it," Elliot said in a reluctant manner.

"See he's fine," Drew said. "He needs the practice anyway."

"Well then ...," their dad replied. "I'm all ears. It's about time you man up anyway, son," their father remarked with a Cheshire grin, one hand on the steering wheel, his other arm rested on the car's glove compartment.

The boy let a heavy sign, "...Addicts are not bad," Elliot said, recounting his speech. "Addicts are not just addicts. Addicts are people. People who are symptoms of their environment and poor choices. Addicts can be destructive and destroy their lives, but with a helping hand, they can change. It is up to...it is up to society to not leave them behind. They are not evil. They are only human. Thank you."

"You did great, Bub. Look at you articulating and enunciating like no other fifth grader I've ever known," said Dad.

"How many fifth graders is a middle-aged father supposed to know?" Drew remarked in her usually smart-aleck manner, a trait she adopted from her father whether he was willing to admit it or not.

Their dad decided to ignore his daughter's remark and continued to drive forward toward the children's first-through twelfth-grade school. Disregarding opposing opinions was something he grew comfortable with since

adolescence. As a prominent local dentist, he made sure stepping on a few toes or teeth never hindered his rise to success. He often thought about molding his children into that same path as his own.

"Thanks, Dad," Elliot spoke with sincerity. Although he often resented the pressure his father put on him to be a man, Elliot couldn't help but crack a small smile at his encouraging words.

"No 'Thanks, sis?'" Drew said. "I practically gave you that push of confidence that propelled you to the likings of Nelson Mandela and Pericles in Dad's eyes," she continued exaggerating as she usually did.

"Wow, Pericles. Pretentious much?" said their dad finally getting his chance to verbally hit back at his daughter's snarky comment.

"What's *that* supposed to mean?" she retorted.

"Honey, I'm just kidding. It's just my intelligent fifteen-year-old daughter is so well-versed in her education that I won't have anything to show for myself. With this new math, new literature, and all, it's hard to keep up with you kids."

"Isn't that how it's supposed to be?" Drew said. "Don't you want your children to be smart? Besides, I am sure you're doing just fine with that new math and literature ever since your dentistry was featured in *Family Circle*," Drew remarked in a slightly taunting manner, as her father wouldn't shut up about it before what happened a few months back.

"Wouldn't have it any other way, dear. Again, I am *just* kidding. No harm done. And if you insist on bringing it up, I guess I am somewhat alright with this new education since your dad's the top dentist in Carter County." He

donned a self-congratulatory smile as he continued to look on with his one hand still straddling the wheel.

Drew could nearly take the eyes out of her sockets and roll them down the street if it weren't for her entrapment in the gleaming cream car. Elliot scrunched his nose, turning once more to look out of the window, annoyed at the obnoxious nature of his father and sister's conversation.

"It's not like you ever *shut up* about it," Drew mumbled under her breath, shifting her body to where she nearly glued her face to the window. Looking outside, she could find the same repetitive suburban nannies carpooling their young ones to school or armies of Adderall-addicted mothers shoving their children's instruments into the backseat of their oversized and overpriced cars. At least it made punch buggy all the more entertaining.

"Who is Pericles?" Elliot asked his dad. At this point, the car swung into the carpool line of the kids' elementary school.

"An old, old man your teacher should know. Go on and hop out of the car before the bell catches you. Good luck on your speech, Elliot."

"Thanks, Dad."

"Drew."

"What?"

"I love you and your brother."

"Sure."

1.1 THE MOORES

I looked out of my window and saw a bird today.
Those little birds with fast hearts. Those two
hummingbirds.
Those two hummingbirds pitter-pattered
around the window where the daisies used to lie,
but it is nearly winter, so it is time for them to
depart. Those hummingbirds don't seem to get it.
They don't understand that it is time to go now,
that it is necessary for their little hearts to burst.
I do not know why they are still here.
It is cool now, but the cold will have its time
to come.
I have rules for my little birds.
Recipes for my little birds.
Plans for my little birds.
They say two should share those little birds, but
ultimately, they always ended up being mine.
This is an ornamental truth.

Drew sluggishly walked down the hallway of the upperclass-man wing of the school. One strap of her backpack straddled her shoulder as she allowed the second to fall behind her back. She nearly lost her balance as her body jolted, tripping over her own shoelace.

"Shoot," she mumbled bending down to tie her shoe in a spare moment.

"How is your mother?" Drew's friend Cherrie asked as she glanced at her friend bending down to tie her sneak-ers. She was the daughter of the Thibaults, relatively close family friends.

"Here we go," Drew mumbled to herself as she rose from the floor, letting her hands flop to her side while she let out a huff facing her friend.

"You care?" replied Drew as her eyebrows shriveled up in confusion.

"...Yes."

"About my *mother*?"

"I mean, *my* mom cares, so I guess I do too," responded Cherrie, lifting Drew's backpack off the ground and handing it to her before the girls began to walk to class.

"Right."

"So your mother, how is she?"

"Well, she's still recovering from the summer, but like she's normal, I guess."

"Is it true what happened?"

"What did you hear happened?" Consistent staring had plagued Drew and statements of reassurance cloaked in invasiveness absorbed her world for the past month and a half. It was as if everybody *knew* what happened to her mother without knowing anything at all. If Carter County's population didn't run to reach the American dream, they sure as hell ran to conclusions in its place.

"I heard she took a bad spill in the kitchen that gave her a concussion. I mean, I just heard that verbatim from somebody else."

"Why wouldn't it be true?"

"I'm not saying it isn't it's just ... isn't that strange how one minute you're cooking and then **boom** your head is in the oven. It sounds like something out of your weird short stories is all I'm saying."

"Yeah it was odd enough hearing it the first time. Plus, my stories aren't weird, they're creative," Drew snapped.

"Sorry."

"Sure." And with that, students began filing into their respective classes to begin the day at the sound of the bell.

1.2 THE MOORES

The lifespan of a hummingbird is three to five years.

My fondness for those hummingbirds continues to grow each time they come to my window, but I am becoming more concerned.

What will they do when winter comes. I tried to warn them once, but they are stagnant.

They wait for the flowers to come, for the flowers to grow. Those flowers will not be back until after winter.

I have yet to tell them that there will be nothing left after winter.

I am fond of the birds because they do keep me company. Company is not warm, but it relieves me.

This is an ornamental truth.

"...Addicts are not bad," Elliot recited. "Addicts are humans. They're people. People who are symptoms of their environment and poor choices. Addicts can be destructive and destroy their lives, but with a helping hand, they can change. It's up to society to not leave them behind. They are not evil. They are only human. Thank you." Elliot rubbed the palm of this sweaty hand against his uniform slacks as he peered at his classmates for the first time since breaking contact with the back wall at the beginning of his speech.

"Thank you, Elliot, for that wonderful speech. It is important that you all realize the weight of those words. It is important that you realize the weight of *all* words," Elliot's fourth-grade teacher Mrs. Lundy stated as she rose from her desk and walked to the front now leaning back and crossing her legs. "You may sit, Elliot," she said, nodding at the boy and motioning her hand to his assigned seat. Elliot began to walk toward the middle of the class catching glimpses of his peers. Some were sweet, most were absent, but the few kids who fashioned menacing glares really wore on his comfort.

"For your homework assignment, we will be having a continuation of Red Ribbon Week." She had placed a series of alcohol and drug addiction prevention posters around the classroom as a reminder of such dangers. "I would like for you all to write entries about what you have learned and how you can implement preventative measures you have learned into your own life. Does that sound doable?"

Collective yeses and the occasional no enraptured the four-walled room. A group of rowdy prepubescent boys giggled in the back of the class. One hand shot up.

"My parents said that no one around here does drugs other than welfare wenches," shouted a future elitist, and the boy Elliot swore to avoid at every chance possible. It was a joke that the child's name was just that ... *Chance*.

"Well you can thank your parents for earning you lunch detention, Chance," Mrs. Lundy sternly replied.

A few giggles erupted in the class.

"I was only saying what my parents said!" Chance said. Elliot looked back over his shoulder at his defiant classmate, who was now attempting to save face from his poorly-timed statement. The boy met his eyes with a grimace as he jerked his body forward in an attempt to stop him from staring.

Elliot quickly shifted his body back to the front of the class where Mrs. Lundy stood. Within seconds, the bell rang. The days had gone by swiftly ever since what happened to their mother transpired, but each time they entered their home, it was as if time slowed down once again. Maybe that's why Elliot yearned to stay in the comfort of his house.

"There's the bell," said Mrs. Lundy "You kids go on now. Not you, Mr. Rush."

1.3 THE MOORES

At the day's end, Elliot shuffled into the family car with his spiky red backpack dangling from his limp hand while his older sister Drew, who was on the cusp of an attitude crisis, followed close behind with her backpack dangling in the same fashion.

Their father had insisted on dropping them off in the mornings ever since what happened in the months prior but was in a committed marriage with his dentistry for the remainder of the day. He had arranged for Stasia, the family au pair, nanny, and housekeeper of sorts to pick the children up from school in his absence. They weren't really sure what she was officially, but she was always there to help when their mother didn't have the energy or sanity to do as she used to before the accident.

As they settled into the backseat, Elliot looked at the dangling stuffed tooth with its own gleaming set of veneers stare back at him from the rearview window.

"I hate that thing," Drew mumbled, seemingly disgruntled about her day as she, too, stared at the odd, stuffed plushy.

Stasia's dainty hand took the opportunity to squeeze the unsettling toy as her other hand remained on the moving

car's steering wheel. With a swift squeeze of the plushie, it began to play a jingle—*Smile Moore! Your smile's a score! Come on down to Moore Smiles Dentistry!* Stasia shifted back to face them. "What? You don't like that tune? I think it's pretty cute."

"It's pretty corny," remarked Drew.

"Ah, to be a fifteen-year-old who hates plushies that sing jingles…" she jokingly responded. "Rough day I'm guessing?"

"Five hundred points to the woman in the front seat," Elliot chimed in, pointing directly at Stasia in a comical manner.

"Elliot," Drew said, "you've got to stop doing that. No wonder you're getting bullied at school."

"I'm not being bullied!"

"Well, you're getting there."

"Hey, hey…your brother just likes game shows and eccentric things," Stasia said. "No need to be rude about it, Drew."

"There's a difference between being eccentric and straight-up socially challenged," Drew said. "Last week he held a funeral for the two hummingbirds he found dead in the front yard. Please pick a struggle."

"Well, I think the ability to sympathize with other creatures is a virtuous trait in young boys and girls," Stasia responded.

"Whatever. All I'm saying is that if he wants to make more friends other than Nikki, you've got to be a little more relatable."

"Well, how about you both relate to this next question: Who's hungry?"

"Me!" they both enthusiastically screeched, setting their differences aside.

"What kind of snack would you all like?"

"Licorice!" shouted Elliot.

"See what I mean!" Drew replied. "You could at least *pretend* we came out of the same womb."

"Actually, no licorice, no snacks. I think your mother made something at home."

Both stopped for a second and pondered in silence.

"Mom made something?" noted Drew.

"Yup."

"Mom?" repeated Drew. "But she hasn't done that in months," she stated.

"Well, while I was leaving to pick you all up, she was playing around in the kitchen, and I didn't want to bother her too much, seeing the past few months have been a bit rough."

"But that's only a thought?" asked Drew.

"Huh?"

"It's only a thought, not fact? Ya know, that mom cooked."

"Miss Sherlock…she's back," Stasia stated.

"Never left," Drew said.

"How are your stories going?" asked Stasia.

"They aren't writing themselves … needs progress though."

"Seems like you're doing quite a good job of sleuthing and interrogating in real life too," said Stasia.

"Confidence is key," replied Drew.

"But what if mom didn't cook and just got out of bed!" Elliot picked up where the conversation left off. "Dad will probably be late from the dentistry like he has for the past few weeks, and I'm starving."

"Did you not eat your lunch again?" Stasia turned around to confront Elliot as the car halted to a stop at a red light.

"No, I ate," Elliot said unconvincingly, "well shared. Besides, I miss Mom's treats. You never put any treats in there like she used to."

"Ok, let's make a deal," Stasia said. "I'll deviate from the essential food groups and learn to make your beloved treats if you stop giving your food away for lunch. You're a boney boy, you need to eat!"

"Fine, but only if you stop calling me a boney boy like everyone else."

The car began to move forward as the light turned green.

Stasia spoke to the children while looking at them through the rearview mirror once more, "Since your mom has been recovering, I'll see if she can teach me some tricks and trades."

"Stasia," Drew and Elliot said.

"Wouldn't that be good?" she continued, still looking at them through the rearview mirror. "I know it doesn't mean much to you two, but spending quality time with you all is more than a paycheck."

"Stasia!" the two children yelled at the top of their lungs as her attention darted back to the road. Her foot slammed on the brake as she nearly avoided hitting a rogue deer. Her eyes darted to the road as they instantaneously grew to the size of saucers.

"Is everybody okay?" She huffed, eyes wide as she looked back at the children, a bit shaken up.

"Yeah," they responded erratically, shaking their heads.

The doe stood in the road in front of the car, as it had halted only a few feet away from the intersection leading into their grandiose neighborhood.

As the trio caught their breath to continue on the now short distance home, Stasia's feet hovered over the gas pedal hesitantly. Shifting the car around the doe, she continued on into the neighborhood.

The doe continued to stand moments after the car had gone. Just waiting.

And waiting.

Elliot turned around peering out the car's back window to see a distinct skid of car tires and a crash terrorize the air. A shiny rover had smashed into the enchanting deer, which was possibly looking for its mother, possibly not. It lay still on the road as blood rushed out of the side of its head, its eyes turning cold. The distance between the car and the deer widened; Elliot's eyes widened as he turned back around settling in his seat in silence.

2

THE MADONNA

———

When a hummingbird dies, their heart is
enraptured with black mold.
 Mold enraptures their hearts—devoid of
buoyancy too heavy to hold them high.
 They fall swiftly to the ground with no wind of
life left behind.
 Death being the only part of life.
 That of which lacks swiftness.
 The heart of the hummingbird—slowly seized
by molten mold.
 Why the hummingbird flies; we know why, why
they perish we will find.

As the car swung into the elaborate circular driveway of 42 Walnut Drive, Stasia pressed on the brake, allowing the vehicle to come to a stop. Opening the back door of the vehicle, Elliot followed his sister Drew out of the car as Stasia stayed in the driver's seat waiting to move the car into the garage. As her pointer finger hit the electronic opener, Stasia swiftly opened the garage and parked the vehicle. Still boggled by their near-accident moments earlier, she

hopped out of the car a bit too swiftly, bumping her head on the vehicle.

"Ow!" Stasia mumbled, rubbing the crown of her head as she entered the house through the garage door entrance. Quickly, she scuffled inside through the narrow hallways as she met the two children at the front door, gliding across the marble floor still rubbing her head in pain.

"Guys, I know what happened was a little frightening, but can we agree not to tell your parents about it? I don't want them to worry, and I really enjoy being here with you all. It's more than a job, it's …"

"Labor?" Drew questioned rhetorically.

"Babysitting?" Elliot asked sincerely.

"A great opportunity."

"Oh, yeah I guess," Drew agreed. "We weren't planning on telling anyway. It's just a deer," said Drew walking toward her room. "Besides, if they wanted to replace you, it would take a lot more than a dead deer for that to happen. I'm pretty sure the entire neighborhood is just as freaked out about working for mom now, just as much as they are intrigued."

"Why do you think they hired a girl not from the neighborhood?" Drew voiced far off, just before entering her room and closing the door behind her. Stasia thought that Drew's words were no way to speak about one's mother but did find her words just as discomforting in their subject matter as Drew had intended.

When 9:30 p.m. rolled around, it would be time for Stasia to head back across town to share a three-bedroom apartment with the rest of the Spice Girls. It wasn't like she didn't have the money for her own place, but it helped her sleep better at night to pretend that her neoliberalism colluded with her charitable front. The market always ensures that

you get what you deserve right? Toy Jeep? She got it. Piano lessons? She got it. Prom queen? She got it. Tuition paid in full? She would've had that too if she didn't insist on working for scholarships instead.

Stasia was always adamant about making her own way rather than relying on the success of her doting parents. When she told her roommates she would be taking a job working as a not so quite au pair for the Moore family, they snarked at the fact she was practically doing it for fun, but Stasia meant well.

The young woman consistently looked for volunteer opportunities around the community. Seeing the Moores' offer for a house helper was irresistible. What was another good Samaritan act going to take away from her schedule and reputation other than a mundane movie night or two? Besides, it was good pay, her own pay that *she* earned.

Stasia reverted her attention to Elliot as Drew's bedroom door slammed shut. The boy looked at her wondering who would be the first to break the awkward silence. She quickly turned toward the empty hall.

"Mrs. Moore, we're home! Mrs. Moore?" Stasia lifted her nose up toward the ceiling only to smell the delicious scent of baked pasta. She made her way to the kitchen to greet the phantom occupying its quarters. There was nobody in sight. On the stove lay a simple note that read, "Dinner's done. Enjoy."

"She's probably taking a nap in her room," mumbled Elliot, walking in behind her.

"Huh," she grunted nodding at his point. "She left some delicious dinner for you all," Stasia noted opening the oven to see a finished pasta dish being kept warm.

"Mrs. Moore?" she yelled in the still house once more.

"Mom!" spoke Drew, increasing her volume as she entered the kitchen abruptly. Both Stasia and Elliot's bodies jolted, startled by Drew's grand entrance.

"I thought you were in your room?" Stasia said.

"I was, but I smelled food and I'm still hungry."

"Go check if your mom is in her room, will you?"

"Why? She's probably…" Drew retorted.

"Just go put your sleuthing skills to good use and do it, please."

"I'll go," rationed Elliot.

Stasia watched Elliot as he exited the open kitchen, slowly moving a few steps behind the boy to keep him in sight. Elliot walked across the foyer and up the marvelous staircase lined with annual family photographs. The progression of photos depicted how half-smiles were enough to make the family photo albums as long as it looked classically presentable in black and white. Stasia continued to watch Elliot as he disappeared down the elongated second-floor hallway.

She trailed behind him up the stairs to the second floor at a distance where she could see him stop at the gateway to his parent's bedroom. Elliot reached out his hand to turn the knob without a thought of knocking. As his finger grazed the shiny brown knob, Elliot quickly stopped and jilted at the sound of his sister downstairs.

"Mom!" Drew yelled from the kitchen.

Stasia and Elliot rushed down to meet the girl standing in shock at the kitchens open archway. All three of them stood and watched Mrs. Moore enter from the backyard door with a pie in her hand. Stunned at first, Drew stood and stared at her mother who she regarded as a hermit in the prior months.

"Sweetheart, you're back!" Mrs. Moore voiced to her daughter as she sashayed over to the oven grabbing a mitten

and swiftly moving aside her pasta dish making room for the pastry. Her head exited the oven with jelly from the raspberry pie staining her hands. The sun from the kitchen window shown on her face only to reveal her sleepy eyes and drab attire consisting of old khaki pants, a cardigan, and bare feet. Her appearance was dizzying compared to the beauty she retained in previous years. Mrs. Moore stared back at Stasia and the kids, as bewildered Bambi, stood in the kitchen looking at her in awe.

"Hi, Mrs. Moore," Stasia said, "we were calling for you."

"How funny, I didn't seem to hear a thing. I was so focused on this pie that I … oh how are you doing Stasia you look so startled."

"Oh no, Mrs. Moore, I was just caught off guard to find you in …"

"The oven?"

"…the kitchen. I didn't know you started cooking and baking again." Mrs. Moore let out an untimely giggle.

"Well, it's been a few months since … I thought it would be fun to get on my feet and finally make something. I spend my days looking at cooking blogs so much that I missed the actual cooking part myself. Here, try some," she continued with a shining smile.

Elliot swiftly brushed past both Stasia and Drew to get a glimpse of the pie still in the opened oven. A tiny yellow flower garnished the pie's top.

"Notice the flower, Bub," Mrs. Moore said. "I thought it would be a sweet signature from our own backyard. Did you know plenty of cooks add their own artistry as a signature to their food? I guess I'm playing around with mine," Mrs. Moore stated with a smile. Still donning that unsettling simper, Mrs. Moore looked at the

three deer in headlights for a response but was met with uncalculated silence.

"Hmm, you all seem hungry. Stasia must not be packing those lunches like I used to, huh?" Mrs. Moore giggled to herself while addressing her son. The woman turned around to look at Stasia for a moment before turning her attention back to her son. "Since your father's not home, I guess I could give you all a bit."

Elliot slowly made his way over to the pie, Drew followed after. The sweet treat was now in Mrs. Moore's mitted palm.

"Are you going to eat some, dear?" she asked Stasia.

"Uh, Thanks, Mrs. Moore. But…."

"Ann."

"Pardon?"

"Ann. I told you, no need for the formality. Just call me Ann."

"Right, sorry … Ann," she voiced with a half-smile still staring intently at the pie.

Stasia sat exchanging glances with the children unsure what to say regarding the offer. She grabbed a fork and let it hover as it sat on the shining kitchen counter.

Drew and Elliot followed suit, grabbing a fork allowing them to hover before looking at their mother who intently stared at them waiting for someone to take the first bite. Finally, Stasia dove her fork into the dessert, grabbing a small corner of the pie and stuffing it in her mouth. The children weren't sure whether to laugh or continue by following Stasia's actions. Stasia watched as a sweet smile grew on Mrs. Moore's face. The woman took off her quilted smock and placed the remaining pie in the glass dessert display.

Mrs. Moore turned around before exiting the kitchen. "It's nice to see you Stasia," she gleamed. "Kids, we'll have some

dinner when your father arrives." The woman continued to walk out of the kitchen and return to her room.

The trio sat in silence before dropping their forks on the counter.

Drew looked intently at Stasia. "It wasn't even cooked."

Stasia quickly grabbed a nearby napkin and spat the piece of raw pie out. "I know," She said grabbing the pie and putting it into the oven.

2.1 THE MADONNA

"Her friends don't even call her Ann," Elliot informed Stasia as he ate.

> My hummingbird outside the window has a maroon neck.
> It was so beautiful when it glistened in the sun during July.
> It's so beautiful, it is the only beauty left behind.
> My maroon-necked beauty. It's so beautiful.

The click of the front door prompted Ann's attention to quickly shift from her faint reflection in the kitchen bar counter.

"Honey, you're back!" She voiced as she stood up from the bar stool and made her way to the foyer to take off her husband's jacket.

"I am, and ready for a snack … Ann? You're up and about." Dr. Moore entered the living room with a slight crinkle in his brow, mouth agape.

"Well, who else would you think it was, honey?"

"I guess it was quite strange that Stasia would be calling me that, but look at me!" He joked with a dry obnoxious laugh.

Stasia and Ann uncomfortably chuckled along as the children looked at him stone-faced.

"Dad, you don't have to man-handle the room," snarked Drew, not forgetting his comment from earlier in the day.

"Yeah, yeah," Dr. Moore dismissed as he kissed her on the forehead, beelining his way to the kitchen briefcase in hand and work clothes remaining as neat as they had been when he'd left that morning.

"Isn't it weird when your mother does that thing?" asked Dr. Moore.

"What thing, dear?" asked Mrs. Moore.

"The way you always know who's coming before seeing them," Elliot chimed in without ever turning his neck from the living room flat screen that he was now lending his attention to.

Dr. Moore directed his gaze toward his son as he entered the living room, crossing the foyer once more with a slice of now cooked pie on a napkin in hand. He playfully hit Elliot over the shoulder as a form of greeting, not granting him the same affection as his older daughter.

"Bub! You oughta get a wife who makes pies as good as this ole thing used to. I'd be damned if it were hers," he said, referring to his wife. Before Ann could reply, he moved on to his next conversation victim.

"Horror ... interesting choice. Do I smell pasta?" Dr. Moore asked. Elliot never redirected his attention from the television.

"There's some in the kitchen," Stasia said with a soft smile. "The family was waiting to eat dinner with you."

"Stasia! Nice to see you. How's everything going?" Drew's eyes rolled as she couldn't fathom her father's obnoxious tone.

"It's going … I mean that not in a bad way but, uh, a lot's happening right now in my life, but it's definitely exciting and interesting!"

"Ah, well that's good to hear. It's also nice to see you bringing some dessert for the kids. That was quite sweet of you...literally!"

"Well. I didn't …"

Still standing in the open foyer, Mrs. Moore turned around to face her husband.

"Actually, I made it," she said.

"Made what?"

"The pie, silly."

As he stopped just before entering the kitchen, he looked back at his wife.

"Really? Back in the kitchen?"

"Mhmm."

"So soon?"

"Well yes, isn't that how you like it?"

"I mean … sure. I was just … making sure."

"Now you are just that. Sure. Have another slice, sweetheart."

2.2 THE MADONNA

*My other hummingbird, it counts its moments
in stars. Before it breaks my heart, I would like to
see it rest for once.*

*Even when it is not at my window, it's heart
thumps so loudly where I cannot sleep, and I have
no choice but to hear it. I know it is always there.*

My other hummingbird breathes with certainty,
even when it lacks just that.

"Would you like to take some dinner with you before you go, Stasi?" Dr. Moore said. "Stasi. I can call you that, right? It has a nice ring to it."

"Never heard that one before, but ... "

"That means no, Dad," Drew said, beaming the same Cheshire smile that he had granted her earlier in the day. "Just FYI."

"Thank you ... for that explanation," Dr. Moore responded.

"Oh no! I didn't mean it like that at all. I mean it's absolutely fine. It has a ring to it like you said, I think it's sweet."

"You would," Mrs. Moore whispered.

"Pardon?"

"I think it's nice for a young woman like yourself to be fond of nicknames. Nowadays, women are being called all sorts of profanities and whatnot. Don't you agree?"

Stasia could feel her cheeks begin to turn red at the sudden intensity of her tone. It was as if she was being cornered but in the nicest way possible.

"Yes ma'am," Stasia said. "A pet name must not be too bad these days." *Should I have said something else?* she thought to herself. *Or was what just happened happening at all?*

"Do you know what people used to call me?" Mrs. Moore questioned.

The entire family waited for a response.

"Doe," Mrs. Moore said.

"That's pretty," Stasia replied. "... Very interesting."

Ann Moore looked at the girl as she dared to blink.

"Thank you."

3

THE FOLLOWING

———

After the children are dropped off and my husband has gone, I sit alone with that girl, the catalyst to the fall of my world. She is smart, she is sweet, but most of all, she is oblivious and painfully so.

She cooks breakfast for the children before they go, including the third—my husband. Leaving a small ration of scrambled eggs and fruit she waits until I scuffle down the stairs to consume the bland excuse for a home-cooked meal. She must have gotten that particular trait from her mother. I never did expect much from the one who bore a bastard.

Unfortunately, for her I never shuffle down those cold stairs, while she waits for me to move in the stillness of the house. Rather, I wait until she leaves me to do as I do. She tends to errand upon errand on her days invading my house; I tend to my own. My errands are not that of the plain house-wife I used to embody, but they are now the obligations of an extraterrestrial inhabiting foreign bodies.

As I peer out my window between the rose bushes, I look down at the young woman entering her car and leaving the family vehicle to me. I swiftly slide on my overpriced Sienna sandals fit for any homebound mother to match a sky blue

oversized button down and cuffed khaki shorts that just hit the knee. I let the young woman enter her yellow Volkswagen and start the ignition, only to drive down the street. Just before I descend the stairs leading down to the kitchen exit to the garage, I look at a family portrait sitting on a table that decorates the elaborate halls of my "home." Elliot, you look so sweet. Drew, you look so sweet. I once looked so sweet. I continue down the hall, down the steps and out the door. I have priorities to attend to.

I walk to the car and get in. I allow the car to start before letting the garage door rise. Waiting for a second or two, I close my eyes and take a deep breath. I meditate like they told me to. Inhale. The car motor hums. Exhale. Now it vrooms. My arms rise slowly to the car ceiling as more smoke envelopes the garage. My hand feels the garage door opener and presses it, and I open my eyes. That's it for meditation. A large waft of gray smoke huffs out of the garage as my car backs out of the large driveway. I finally get to begin my game of cat and mouse, where I begin to trail where the young woman goes. Stasia where could you be going? This is *my* old routine; grocery store, cleaners, gas station, and I would usually assume back, but she deviates here and there. As I pick up her beat and tempo, I am getting to know her better.

Stasia I am getting to know you better. That's all.

It is my new obligation to follow her after her departure and arrive before her return.

It's a wonder that a family so "concerned" over their wife's and mother's wellness wouldn't dare take extra precaution to ensure that she was well looked after or to make certain her head doesn't find its way to the oven once more. Damned if I do; damned if I don't.

For years, I remained devoted to things the world told me I should, yet I am repaid in resentment and passiveness of insincere gratitude. I am destined to be a fossil in my own house; I reject the unholy trinity that occupies my so-called home.

This is why I follow, this is why I observe, and this is how I will absorb. I know I am replaceable now, but I intend to be replaced on my own terms and for that to happen, I must find the right successor.

There is no better successor than a spare.

3.1 THE FOLLOWING

> *Does the hummingbird know that it is prey?*
> *That it is collateral.*
> *It's a wonder if the hummingbird notices it at*
> *all—It's a wonder.*

My return home marked an end to the following of Stasia Pritchard, but I fall into another.

If I'm being frank, Stasia Pritchard is a superficial name. If I'm being trite, Stasia Ann Pritchard is a name that is even more square, even more so than my own. These days you can do much more outside of the realm of reality. Attend your neighbor's son's first birthday. Holiday shop. Attend your high school acquaintance's wedding. Go on a holiday to Nice, France. Order dead animals. Make appointments. Make friends. Make lovers. Make enemies. You can do it all. All you need is time. No wonder so many people assume

the complex of God. I never choose to wonder. I would rather know.

A digital trail is so vast, but it often dwindles down to social forums. One shouldn't hate them as they do serve a purpose, but one should wonder what that particular purpose was for. Some people search for recipes online; I do that. Some people search to save time; I do that. For me, I know what my purpose on the internet is for. For my stealthy pursuit. To get to know Stasia.

Stasia Ann Pritchard.

Screen name @stasia.pritchard. Caper High Alumni, Principal's Cabinet, Dean's List First Honors four years in a row, Miss Debutante Queen, Princeton Alumni, Red Cross Advocate, UNICEF Volunteer, and freelance poet residing in Carter County, and part time nanny.

If it weren't for her doe-eyed beauty, the world would swallow her whole sooner than later, despite having that myself, I look in the mirror and see worms squirming out of my ears each day. I guess desirability can buy you out of being scathed by a mean old man's world.

Interesting what people decide to display and what they don't. I thought she wanted to pardon herself from the silver-spoon-fed child she was destined to be by becoming a nanny on top of all her public service. Or maybe that's one step too far for the public to see according to her family and friends.

"Sure, have a heart, but don't make your play practice," I bet they say to her. I wonder if she believes it. That is what I must know. But the one thing I am already sure of is that even a girl's perceived image lacks autonomy. I bet that's the most authentic thing about Miss Pritchard.

3.2 THE FOLLOWING

Smother the hummingbird in a sky where it is the only silver lining.

Stasia Pritchard is a girl with potential, nonetheless. She is the spare to me. She will be my successor.

3.3 THE FOLLOWING

A world which smothers will always win.

When I was a small child, my desired occupation was to be a trophy wife like my mother and my mother's mother. Not to be mistaken for a housewife, I fawned at the idea of creating a picturesque family, while following each and every footstep of her husband, Prince Charming. Nice homes, lovely gardens, and uniform culs-de-sac were everything to aspire to.

My small self often questioned who wouldn't want to be the matriarch of her own kingdom. Provisions saw no end, and no end was something on which to depend. I completed daily tasks of positioning each of my dolls as family units of their own on the window seat in my room.

Nestled at the edge of the window was my favorite doll, Julie. The infantile Cabbage Patch took the crowning spot as the mother. There I could see the beauty of her front yard's rose bush, which her father had planted. Outside the window I would often gaze at a tiny hummingbird's wine-colored stain just above its neck. The steady footsteps of her father

inching closer up the parkway toward the home's entrance broke her gaze on the bird's enamoring beauty.

With a swift click of my family's white picketed front door, my Cabbage Patch slipped off the windowsill and was met with the numbing wooden floor. My smaller self scuffled from one side of the room to the other and peeked through the cracked door, which faced the living space down the hall. I watched my father pick up his briefcase that was left behind earlier in the day, and I could not help but wonder why he exited the door without skipping a beat. He only once stopped for a moment to look my way, seeing my tiny eyes peek out from the cracked door of her room. But now that I think about it, my memory becomes more fuzzy upon recollection.

As my mother swiftly walked in front of him to ask where he was headed for the night, my little mind couldn't remember any sounds other than the whimpering coming from deep within her mother's throat. No face, including my own mother, could stand in the place of my father's towering figure to stop him from leaving. I folded at the sight she witnessed but could not yet fully understand. Shutting the door behind me, the little girl didn't remember hearing much more that night other than the silence that absorbed her.

Minutes went by, then hours, and days that turned to months. I still remember that wine-stained hummingbird outside my window, and how it never came back after that day. It had lost its way until just before my accident and comes to visit me once more. At the sight of a hummingbird, I remember how cold the floor had been on that warm July evening. That young girl who used to be a part of me came to the realization that a kingdom was just that, the home of a king and no one else. Although the sun rose at dawn that

following day, in the place of a home lay an exoskeleton of a house, and all would never be the same.

What is it to be a girl, a woman, a housewife,
and a lover?
What is it to be just that and none other?
A girl I am
I am obedient, sweet, sized as a pint, true
Subservient only to you
A woman not, a girl is no longer what I am
I am fresh, youthful, capable, true
Subservient only to you
A woman I am
I am structured, ripe, willed, and strong
In addition to my life song, in addition
I am love, lust, heart, glue,
but still I am only subservient to you

4

THE MEETING

———

Who would believe that with such an unbearable sense of humor he would be such a handsome man? The pinnacle of paternal humor had been crystalized in time by the fact that Dr. Moore's own name was a slogan for dentistry. *Smile Moore! Your smile's a score! Come on down to Moore Smiles Dentistry!* What more smiles can you have other than one? What kind of man is Mark Moore? It is said that you marry the wrong man, that's too bad, marry a banal one, that's on you.

4.1 THE MEETING

Spring was just becoming when Mark Moore met Ann Presley on the twentieth of March. Mark accompanied his then girlfriend Lucille to Myrtle Beach for spring break, a soon to be literal translation of their relation. Mark entered his family's beach house with vigor in his heart and lager in his hand. As Lucille and his path forked, he felt that his day would be memorable. A few beers, a few sneers, a glancing eye, and affirmation that he was in fact a "nice guy."

How he swept his "doe-eyed dame" off her feet through a game of heads or tails was Mark's favorite story to rehash. It was enough to prove his bold nature while veiling his unrequited advances. Much to the dismay of bored colleagues, neighbors and patients unable to leave their root canals unmanaged, everyone in Mr. Moore's vicinity was subjected to a story that went a bit like so.

"So I was getting a bit hungry and what's her name, uh, Luci," Mark would gloat.

"Lucille," a friend who was all too familiar with the story would say. As if he weren't a broken record Mark's forehead would crease with confusion. "Come on, you can't even remember her name?"

With an ounce of awareness Mark would continue. "As soon as I saw my wife, it was enough to forget how to speak!"

A cue of forced laughter cloaked in annoyance usually followed.

"I walked into Sunnyside diner, been there thirty years and probably thirty more. As soon as I walked in, I see this huge marquee with all the platters of the day. Salisbury steak with green beans and potatoes, Philly cheesesteak with potato chips, and well I'm getting carried away with all the food I should've tried to get the chef's number instead," he'd say after laughing at his own joke.

How amusing.

Mark would often continue by remarking, "Right as I began to take my seat at the bar a huge gleaming smile blocks my line of vision. It's the manager ... Belinda. Should've called her big Belinda if you ask me. But behind her ... behind her was Ann. She walked up and said, 'May I take your order, sir?' And I replied, 'Do you know we have the same last name?' She looked down at her name tag and claimed, 'Ann is not

my last name, sir.' And I replied, 'I know. Your first name's Ann, last name's Moore. Ann Moore.' 'That's not my last name either. I'm sorry you're mistaken.' So, I said, 'I know it's not now, but it will be.'"

A chorus of dry coughs prompted by Mr. Moore's "romantic" tale and maybe a rare exclamation of "smooth" usually followed his recount of sweet talk.

"So, what happens next pretty boy?" the listener would bluntly ask.

"I asked her out, and she said yes."

"Just like that, huh?"

"Just like that," he would always say donning a self-congratulatory and gummy smile.

"I took a coin out of my wallet and said, "Let's make a bet. If I flip this coin and it lands on heads, then you have lunch with me, and we go from there. If it lands on tails, I'll forget about lunch and walk right out of that door. How 'bout it?" She happily agreed but had to move fast since she was on the clock. Little did Ann know she would never have to worry about working another day in her life if the coin landed in her favor—heads. With the flick of my thumb the coin flew into the air and landed on the cold counter and boom, she was mine."

"So who did you leave with?"

"Who do you think?" Mark questions with a dopey smile.

The conversation usually went just like that. Again, and again until his pride could take no more until the next time.

4.2 THE MEETING

So easy for him to drop one and pick up another, but this girl would be different. She was stable, hardworking, and had a lovely glint in her eye as if she held the key to the wonders of life.

For years he would look at that glint in her eye and see a reflection of himself, a reflection that held standard, responsibility, authority. To him, she had always been a good wife abiding by her duties, going above and beyond, taxing her pride and free will, fulfilling the role of both poster mom and pin-up princess that he "knew" all women strove to become.

When Drew wanted her fifth birthday to be Strawberry Shortcake themed, Ann made their daughter a two-tier shortcake from scratch.

When Dr. Moore had to be at the dentistry earlier than expected, she made sure to drive the children to school. When the infants wept at night, she was there to make sure everybody got sleep.

When Elliot broke his arm and Dr. Moore was too busy to care for his son, Ann was dad and mom.

When Drew was three and he left her in the backseat of the car—she was still there.

Ann did not get angry, she did not threaten for divorce, she didn't call the authorities, she did not even cry. She just picked up the empty Heineken from the front seat of the car parked in the driveway and brought her crying daughter inside. She walked her daughter calmly upstairs to her cool crib, two baby bottles in hand.

Her hair disheveled, her bare feet scuffed by the concrete, and her body drenched in sweat were juxtaposed to her calm demeanor, but no glint was visible in her eye.

He vowed to never do such a thing again and he didn't. Things went on and life continued, but the seasons rolled by without fruition. It was clear that Ann had always been the keen target of Mark's infatuation. A clean slate that could be projected, but those ideals he held over her head were soon to be the reason why she lost it. In her eyes' reflection, he could see his image washing over with disdain and resentment of her "happiness." While there was all to be happy about, why was he so discontent, and why was there a need to look for more? He loved everything about her, but one must love something before they get to hate it.

4.3 THE MEETING

"You know, my wife and I have been thinking about your wife a lot. If there is anything we can do for you, just let me know," Sebastian Thibault insisted while speaking to Dr. Moore as they walked across their community golf course.

"We appreciate it, Sebastian, but, uh, you've got us drowning in orchids as if someone died," Mark stated.

"If I had to ask my own wife, she'd say so herself."

"Besides, she prefers roses. I guess if Ann did die it would be better to drown in flowers rather than sticking her head in the oven."

"A bit morbid much, Mark?"

"Sorry, it's just been a bit stressful taking on some of her roles in the house. With her being out of commission, it's a bit rough for me in a few ways. It's just a joke, you know I didn't mean it that way," he said, exhaling while uncomfortably rubbing his chin with his palm.

"It's understandable. Couldn't imagine how it felt for you finding her like that though. So, how is the new nanny slash housekeeper or au pair situation working out for you?"

"Ann actually found a girl that we're seriously thinking about hiring here in the next week. Name's Stasia, Princeton grad, stuck in some part-time gig up on the hill for the meantime, but according to her résumé, she has a great head on her shoulders. Didn't read it though, just let Ann handle that. Apparently, she's a poet of some sort and offered to show Ann some of her work, but honestly, we just need someone who's willing to do the job females are meant to do. It's just different for women, you know?"

"Yeah … So, her name's Stasia huh? Let's see her."

Dr. Moore quickly kept up with the tune of the conversation and swiftly pulled up a photo his wife had exchanged with him to quench Sebastian's curiosity.

"She's … "

"Attractive?" interjected Mr. Thibault.

"You said it, not me."

"You were thinking it."

"Yeah well, I better get going."

"I guess I should head home too before mine starts nagging."

As the two men began to make their way off the course, caddying their own clubs through the sidewalks of their neighborhood, Mr. Thibault stopped in his driveway and looked back at his neighbor with one last question.

"Hey, Mark?"

"Yeah."

"My wife's been talking with the other moms at school and is at a loss for words about what to say about Ann—do you really think your wife really meant to do that?"

"I better get going, Seb. Good night."

Mr. Thibault threw up his arm to say goodbye and retreated to his front door "Right. Goodnight." Mr. Thibault took another step and stopped once more turning to his friend one last time.

5

THE KIDS

—

Drew could hear the garage door shut, the clack of dress shoes on the floor, followed by the sound of something sliding across the kitchen counter. The sound of glass shattering came from the kitchen. Drew looked at her brother as they heard their father loudly sigh and mumble about the unknown location of a broom and dustpan to clean up the mess.

"That must be Dad," Drew remarked from the living room sofa.

"Or a robber," replied Elliot as he lay in a ball in an armchair watching television, his head not shifting for a moment from resting on the arm of the chair. Drew looked at her brother once more from another couch creasing her brow.

"What robber would take the time to open the garage, close the garage and then come in through the door, smart ass?"

"Language!" shouted Dad.

"Sorry," the two voiced in unison.

"Why'd you come in that way? Didn't you walk here?" questioned Elliot.

"You should listen to your sister, son."

Elliot gave his father, who was now walking toward the living room, a disinterested look.

"Haha," added Drew. "But you know, Dad, he has a point. Why would you go through all that trouble opening practically two doors when you could've just gone through one? The front door works just fine. You know your character type is antisocial based on your actions … maybe even bordering on sociopathic behavior."

"I am not one of your fairytale characters, Drew."

"Mystery short stories," she corrected swiftly.

"Why would he be a sociopath?" questioned Elliot, "You watch one too many criminal forensic documentaries and think you're a psychiatrist."

"Do you even know what all of that means at your age?"

"I seem to know more than you."

"Either of you kids think about helping your father clean up that mess? I can't seem to find the broom or dustpan … Drew?"

"Why are you asking me?"

"You're the oldest," replied dad.

His statement was met with an eye roll cloaked in irritation from her. As he made his way to the other side of the couch to finally relax he prompted his children with a rhetorical question in an attempt to chime in with their previous conversation, "Does your father *look* like a sociopath?"

The two children both stared at him with a deadpan demeanor and responded with a swift "Sure."

He looked back at them perplexed with looming unawareness.

"I mean the news said that almost anybody you know could be a sociopath. They don't have a specific look," noted the girl.

"Roughly one in twenty-five people can be one," added Elliot.

As soon as Mark had the chance to sit down he swiftly got back up. "On that note, I'm going upstairs."

"Literally, who are you? A man-child? One in twenty-five?" questioned Drew to her younger brother from the sofa.

"What? You remembered what the news said, too!" Elliot retorted.

"Statistics? That's a real conversation starter."

"Why do you even care? It's just Dad."

"Look I'm trying to help **YOU** out."

Their dad made his way up the U-shaped staircase and took off his state college cap.

"Drew! Quit nagging. You can take out the kitchen trash or something," Dad hollered whilst climbing up the stairs.

"That's not my job and what about Elliot!" she shouted back. Drew inched off the couch deliberately walking in her brother's field of view as she made her way toward her room.

5.1 THE KIDS

Mark continued up the stairs and down the hallway toward the bedroom. His skin was showered with the evening sun rays pooling in from the window.

"Sweetheart?" he called as he opened the door.

The bedroom is was neatly in place, as the bed lay eerily empty without a crease in the duvet. Mark began to make his way toward the restroom, he slowly peeked through two doors leading to the bathroom where he expected to see his wife, but instead he was again met with emptiness.

Just as he decided to investigate the whereabouts of his wife, he shuffled past the bedroom window that offered a

view of the backyard. Mark caught a glimpse of Stasia and his wife speaking to one another at the backyard tea table.

Since when do they have anything in common? How did Stasia manage to get her out of the house? What would they be talking about other than me? What about me would saying? Staring intently at their body language, he failed to contextualize the nature of the conversation.

The sun rays hitting the window blinds cast a yellow shadow on his face reminiscent of bars. He could not get past his curiosity of what they had to speak about, and why it bothered him. That train halted as Stasia's attention met his own from the backyard below.

She looked up at the window with a quaint smile. The back of Ann's head began to slowly turn as she met her husband's eyes; she too smiled and slowly turned back around to take a sip from her cup.

It was only appropriate for Mark to go greet his wife and Stasia despite his increasingly unsteady feeling. With reluctance, he made his way down the stairs he had just climbed moments before, making his way through the hallway and through the door leading to the backyard.

"Hi there, sweetheart," he mustered with a forced smile.

"Hi, honey."

"Good evening, Dr. Moore," Stasia greeted.

He nodded and smiled. "So, you two have been out here talking, huh?"

"Your wife has been giving me a few tips and tricks to her dessert recipes. You know she's very talented."

"I would know. Clumsy too," he stated with an awkward laugh.

Stasia shyly looked to the ground in response to his offbeat joke. Ann flashed a small smile his way, seemingly ignoring his tastelessness before turning her attention back to Stasia.

Mark cleared his throat before stating, "Well, uh, the sun's setting. Seems as if it's going to get dark soon."

"Seems so, she was just on her way," said Ann.

"That's right," Stasia agreed. "I have to get back to my apartment. My roommates and I are having a movie night."

"Oh, what will you all be watching?"

"*Rosemary's Baby*," interjected Ann without skipping a beat or even looking her husband's way.

"That's right," said Stasia, smiling.

Marked paused for a moment, unsure what to say.

"Hm, interesting choice. Well, it was so nice to speak with you and get to know one another a little better."

"Likewise," stated Ann.

"Here, we'll walk you out," offered Mark.

"That's sweet," the girl stated.

Before Mark grasped the chance to follow her footsteps, Ann was on her tail. As they walked inside down the long hall toward the foyer, he watched Stasia's hips shift side to side gracefully. The line of her body was neither hunched nor crooked. It was as if she glided across the marble floors. A trait his wife once had but couldn't seem to recognize any longer... until now.

He watched his wife following her toward the door seemingly mimicking her walk with each step. He wasn't sure if she was trying to attain the spunk she once had or if he was just going mad.

They bid their farewell from the grandiose door to the unassuming young woman as she hopped into her yellow Volkswagen. The car had driven out of sight prompting Mrs.

Moore to make her way back toward the yard where she was to clean up the lavender tea.

"So, what else did you two speak about?" questioned Mark. "Curious?"

"No. I just didn't realize you two were so close."

"We aren't, that's why we were speaking. We were getting to know each other as one does."

"I get that, but … I mean she's the nanny here to pick up after us and look after the kids while you fully recover. Look, I know that it relaxes you when tending to the family, but just leave it up to her for the meantime."

She paused at his statement as if tending to the family was leisurely and not an obligation that they both should share.

"Well, it's not like I can't have a friend."

"You *have* friends at the book club."

"I thought you said they've been talking about me."

"When did I say that?"

"To Sebastian, over the phone once."

"Oh, he and Harlo have just been worried about you and wondering what to tell everybody."

"There isn't much to tell."

"That's exactly what I said!" he stated ecstatically in agreement gently patting his wife on the back. Although, he wasn't quite sure if that statement were true.

"Anyway, I enjoy her company."

"Me too—I was just saying."

"Why are you trying to get at her before I do?" Ann slyly questioned as she made her way indoors with the fine china to the kitchen sink.

"What?"

"This is where you laugh, honey."

He mustered up an insincere laugh, still wondering what the women were up to.

"Long day," he said.

Mark decided to retreat to the refrigerator to look for a bottle of water.

I'd give anything for a beer right now.

Exhaling loudly and grabbing water, he shut the door and let out a holler. Behind the refrigerator door stood his son Elliot with a blank face.

"Elliot!" he exclaimed. "What the hell are you doing standing there?

"I don't feel so good."

"Why are you telling me this?"

"Because you're my *dad*?"

"Right," Mark agreed, his heart still palpitating.

"Did you ask your sister if we had any pain medicine?"

"She said how should she know?"

"What did you eat today?"

"Just dinner and dessert?"

"You probably Hoovered your food like I used to as a kid. Go crash in your bed son."

Elliot retreated to his room as he was now the only one left in the living room. As Mark calmed down from that sudden fright and collected his thoughts, he swore that out of the corner of his eye he could see his wife fashioning a heavy-browed look of insanity. He turned to meet her eye as her slight grin faded, and she began to walk up the stairs toward their bedroom.

"I'm turning in early. Sweet dreams," remarked Ann.

6

THE AUCTION

Is it not comical when a memory so dear to someone's heart is aimlessly misremembered and in turn misconstrued? It is one thing to only remember the good parts, but it is another to reconstruct the good around you in a narrative.

If it makes Mark feel any better, he can remember the first meeting as told by himself. Here is the telling of how it really went.

You can have your cake and eat it too.

That spring day, the fresh-faced version of myself clocked in for a nine-hour shift at the local diner called Sunnyside Diner. Being from a few towns over, I attempted to keep afloat between sacrificing breaks to earn cash for my studies. The experience of many college boys pumped up with testosterone, eager to harass me on the clock was all too normal, but I guess that's an unwritten rule of any job.

Reeking of Budweiser and giving the impression that they needed heavy doses of Adderall, I first began slipping small amounts of salt at the bottom of their drink, enough to where they were unamused by the taste of food and service, then eventually waned off and out of the restaurant. How's that for a surprise in your Happy Meal? Those forced "conversations" prior to their exits consisted of flirtatious advances, where they treated each waitress as subservient beings. But it's all "part of the job," or maybe they were games that allowed them to exercise power over the waitresses as long as they did not wish to be fired. I absolutely hated it but continued to play the game that I would rather win than lose.

"How about you get me another key lime milkshake and put two straws in there for you and me this time?" a poorly coordinated collegiate kid said.

"Whatever you say, … sir." With a half-smile, I would retreat to the back of the kitchen to add a sweet kick to their drinks. First, a swig of vinegar or a pinch of chili powder, or maybe it was dash of expired milk, or maybe a piece of dust. I can't quite remember as it all garnered the same reaction of an unsolicited wink or touch on the hand. Crushed anxiety pills that I'd rather do without soon topped off the recipes, but before I could carry my concoctions any further, Mark came along. Something about that man intrigued me.

It was toward the end of my shift at Sunnyside. The big marquee behind me was plastered with specials. Belinda noted that the soup of the day was Wedding and ham with melted cheese was the main platter. A towering, broad-shouldered figure strutted up to the diner bar with an overconfident waltz and mission in mind. By observing his overzealous stance and gleaming smile, I wouldn't have assumed he'd be

bothered with any girl, but I don't reckon he'd care enough to notice such a thing.

Lucky me. I had managed to walk to the front with my special milkshake cocktail for a patron at the end of the bar. I served them swiftly and went, to their dismay, to take the order of the man I'd soon know to be Mark. His gaze bore a hole into the side of my face until I disappeared behind an uncaring Belinda.

"Here's your menu," Belinda said bluntly as she plopped down the specials of the day on the counter. "Now can I take your order, son?"

Pointing his slender finger he voiced, "I was hoping that *she* could take my …"

With a quick eye roll, Belinda was off to the next guest pen and pad in hand.

Like clockwork, I walked up to him, knowing this ordeal all too well. "May I take your order, sir?"

"We have the same last name."

My forehead must've formed a large question mark because he continued with his seemingly factual statement. "Your first name is … Ann," he said pointing at my name tag, "Last name's Moore. Ann Moore."

"That's not my last name. I'm sorry, you're mistaken."

"I know it's not now, but it will be."

A long dead pan pause washed over the conversation. After his proclamation that was met by sore silence, he took a quarter out of his back pocket.

"Sorry sir, but the most you can get here with a quarter is water and that's free."

He stuck his hand out for her to wait in silence. With the flick of his thumb the quarter flipped into the air and landed with a clack on the acme chrome bar counter. He slammed his hand on the coin before she could catch a glimpse.

"Heads or tails."

"What?"

"Heads or tails …"

"I don't know what this is about …"

"Just choose."

Belinda inched dangerously close from waiting on an older couple out on the patio deck. My eyes shifted from her to him, again, her to him. "Heads."

With that, his hand lifted off the counter to reveal the coin had landed heads face up. A wave of relief washed over me maybe because the ordeal was over, or maybe because I'd allowed for something to actually happen.

"So how 'bout it?" he questioned. "You have lunch with me."

"Look, I'm on the clock."

"But you have to come off the clock sometime, don't you?" Another awkward silence settled between the two of us, more so for me than Mark.

"Well let me treat you. It would be an honor," he remarked with that same obnoxious gummy and bright beaming smile.

I found him charming and handsome, and although he did not give me much of a choice, he beat out the crowds of men and boys that would use me as a servant rather than treat me like a lady. This was being treated like a lady, I suppose. His stare didn't let up.

"Okay, I'm off in two more hours. Do you think you can wait until then?"

"No."

"Well I'm not sure what to say, sir."

"I'm just kidding, of course. I'll just be around and meet you out on the …"

"Patio's fine."

"Ok, then the patio."

"Two hours?"

"Two. "

"By the way you can drop the sir. My name is Mark."

"Okay then, *Mark*, two."

With that, the time flew by and I had forgotten about my key lime cocktails from hell. When it came time to clock out, I folded my apron nicely in my dingy bag and messed about with my hair to make up for smelling like patty melts and grease from the entire day. Anxiously, I hit the corner and saw him. He was posted with a distraught looking girl who seemed more than a bit irritated.

"What do you mean you're spending the evening with someone else?" the girl said louder than she probably realized. "I came all the way here with you and you dump me for who? A *waitress*?"

"I thought you and I were on the same page," he said to her. "We want to explore and have fun. Besides, it's just spring break. Everybody's just hanging around. You knew this was bound to happen."

As Ann stood there eavesdropping on the conversation, she pondered about what she was witnessing.

"You don't just ask a girl to go on a road trip with you to stay at your family's beach house and **leave** her the second day you arrive."

"All I'm saying is that your friends are here too, so either you can stay with me or with them."

"Yeah, stick that excuse where it doesn't shine."

"Glad we figured it out, Luci," Mark said as the girl walked off.

"It's LUCILLE."

"Right."

Lucille got into her car and sped away, making eye contact with me as she drove into the street. Her eyes scoffed more than conveying any anger.

I stayed back for a bit to collect my shambled appearance and wondered if following this guy, whom I barely caught the name of, was even worth it. No man had ever stuck around or even gone to so much trouble to gain her affection *this* way.

I finally managed a flat, "Hi."

"Hey! It's nice to see you out of the apron, although I do love a woman in uniform."

He made me laugh. Why would that ever make me laugh? Maybe he was never funny at all for all these years and was just an utter goof. He seemed unfazed about the prior episode that just happened between him and the other woman, which is a trait he would keep as years passed.

"So how about that lunch or dinner or whatever you'd like is on me."

"Anything, but here," Ann voiced.

What I wouldn't know is that those same words would hold the same sentiment regarding the life I had built with Mark Moore. Enough would never be enough.

6.1 THE AUCTION

With the arrival of two hummingbirds comes
two more and four more will. It is a circular cycle
that never seems to end unless an intruder comes
along on which we can depend.

7

THE PURSUIT

———

"Long time no see, stranger," Micah spoke as she shuttered her white oval sunglasses at Stasia as she entered the house.

"What's that supposed to mean?" Stasia said.

"Oh, I don't know, '*Miss I have to pick up the kids or I have to help with a shopping errand.*' When did you go on maternity leave?"

"Since when did people wear sunglasses indoors?" Stasia retorted as she made her way to the kitchen island and began cutting apple slices. She scoffed while throwing an apple chunk into her mouth. "You know, maternal instincts are a great trait to have. It's considerate and caring." Stasia continued to cut apple slices on the kitchen island.

"Sounds disturbing," said Micah in a kidding manner. "I'd rather just not care like I've been doing for the last twenty-something years of my life."

"Wow, that's great to know. Now, can you pass me the cinnamon, and do we have any nutmeg?"

"Does it look like we have any nutmeg?" chimed in her other roommate Penny, who took a seat at the kitchen island.

Stasia ignored her while making her way to the pantry.

"What are you making anyway?"

"Apple pie."

"Thank you," said Micah.

"For what?" questioned Stasia.

"The first slice. It's so considerate of you to donate to the hungry residents of apartment 2503," replied Micah.

"First off, this is my first try. Second, donate to the clean-dishes initiative. Third, you're not getting any," said Stasia.

"Why?" Micah said, annoyed at the response.

"I'm making it for Mrs. Moore. She gave me the recipe, and I wanted to return my gratitude for teaching me a few things. Matter of fact, it's for the entire family."

"And what about *this* family?" Penny said, sarcastically putting her hand dramatically over her heart. "You missed our movie night. Where were you? We were here waiting for you, but by the time you would've gotten back, Rosemary's baby could've been a full grown adult."

"Time slipped away. I was just running a few errands," replied Stasia.

"Errands? Late at night? In this 'Whoville' town?" asked Penny.

"Your sex life is none of my business," chimed Micah, "but I suggest you stay away from *these* men. Been there. Done that. Regret it? Slightly."

"I wouldn't do something like that, Micah. Matter of fact, I didn't do anything like that. I said what I said. Errands."

"She's just kidding," Penny added, "the farthest that she's gotten with a Carter County man was a date where he suggested cash in return for consistent foot pictures."

"Traumatizing to say the least," Micah said, "but integral to my developing image as a sugar baby. You know there are so many men out here who have it all but just can't get enough?

I guess, whether I mean to or not, I could be on the verge of ending marriages one baby toe at a time."

Stasia and Penny just shook their heads and continued searching for the nutmeg.

"Seb2212 was his name? Loved golf, fishing, and feet?" asked Micah.

"Well, didn't he make quite the catch," voiced Penny.

As Micah grabbed her water bottle out of the fridge, she bent to Stasia's navel and lifted up her shirt, only to be rejected by the swat of her roommate's hand.

"What are you doing?" she bewilderingly questioned.

"Oh, just checking to see if that C-section scar has faded any since you started playing mother and all."

Micah and Penny continued their laughter as they headed to the living room. Stasia picked up a slice of apple and aimed it at the back of Micah's head, nearly hitting her as she knocked over a pile of unorganized spices on the counter.

Stasia watched her roommate Penny look down and taste the unidentifiable spice that had been wasted. "Mmm. Nutmeg!"

7.1: THE PURSUIT

Who is warm and who is cold? Will I ever know?

After Stasia had driven her tiny Volkswagen out of the cul-de-sac and into the streets, she took a right onto Asher Avenue. She cruised around the city aimlessly for about thirty minutes until stopping at a local grocery market. She passed two pharmacies and several gas stations but chose to stop at the one with many flowers for sale at the front.

She walked in and spent quite a bit of time roaming around the store. Two packs of sunflower seeds and a tea. *She seems the type. Here we go, cruising once more up and down the streets of the city. Stasia, this wasn't your usual route.* She drove into a cozy subdivision near the edge of town where she stopped.

She knows this as home, but to another, it is ripe in their soul with resent. As she entered the two-story house, a car passed the house and parked a few houses down.

The home was lackluster in comparison to what Mother had, dare I say dated, thought the person trailing Stasia in the car.

The silhouettes of Stasia and a woman embracing could be seen through the window. One-third was missing.

How does the saying go? Behind every man is a strong woman? So where was the patriarch?

Twenty minutes, thirty, forty to an hour. The time passed, and the silhouettes faded until a light near the back-kitchen window illuminated.

It was a man about six feet in height, an older man who he took his time in the kitchen. He carried a vase full of water in one hand and the bouquet of roses Stasia had brought them in the other. He placed it on the living room mantle where a family portrait sat. Stasia said her farewells and exited the home, grabbing her charmed necklace as she dropped a small box into her purse. The occupant of the strange car parked at the end of the road started the ignition and circled around as they drove closer tailing the girl once more. Only two things swirled in their minds as they followed her out of the neighborhood.

Had the floor of their home ever felt unusually cold with the absence of one or did that only apply to her own abandonment?

7.2: THE PURSUIT

I'm your little sweet. I lend love. I give love.
Reciprocation is not indicated within a
fair relation.
 I'm a little sweet, and so is she. He will be he
will be.
 Though today and tomorrow I am only your
little sweet.

Over the course of a few weeks, Elliot had been awakened by a tickle in his throat. He thought to himself that maybe his mother had been right to tell him not to drink after others, but his sister was fair in her advice to engaging with his fellow classmates.

Steadily, he gained better relations with his peers who had previously seen him as a shy and slightly peculiar boy regarding his interests. Backwash didn't kill him then, so it wouldn't kill him now, right? He rolled over in bed to see 3:45 glowing from his clock; the red numbers were the only light penetrating the pitch-black room. He rose from bed to begin his search for water; each step he took gentle.

He walked down the stairs with carefulness, past the living room, across the hall leading to the foyer and into the kitchen, where he stopped in his tracks as he could see the outline of a woman standing in front of the kitchen refrigerator. It was Mother. Before he had the chance to quench his thirst and soothe his sore throat a foreboding feeling washed over him. He watched as Mother stood in complete stillness in front of the refrigerator for an entire minute.

Tick.

Tick.

Tick.

Tick.

Tick.

Tick.

Tick.

Tick.

The clock had promptly shifted from 3:50 to 3:51 a quick jolt and Mother's body turned to meet where Elliot stood perplexed by the strange antics he just witnessed. Elliot stifled his heavy breathing as he hid behind the wall separating him from Mother. The twist of her body was paired with a grim smile forming on her face. She stared intently at the glossed floor where her son cowered close by. The dark circles beneath her eyes bore a hole into the spot her eyes terrorized. Elliot waited for what seemed forever.

3:52

3:53

3:54

3:55

The time that passed proved to only be three minutes, which Elliot used to collect his already-hazy thoughts before peering back at where his mother stood in a trance. He braced himself and looked behind the wall and was met with emptiness. She was gone, just like that. With no individual in sight, the fridge remained wide open, confusing the young boy. He took a cautious step closer to the appliance; he could see a lattice pie ready for baking. He stood in the spot, perplexed at his mother's actions. He doubted whether he was awake or in a sane state or not.

He decided to grab water and hastily return to his room. Upon his return to bed, he took a huge gulp and then lay stunned until fifteen minutes past four. Had his mother gotten worse once more, or was it a fever dream that accompanied his impending sore throat?

He contemplated the idea of ignoring what he may or may not have seen before he began to doze off. Eyes fluttering shut, he resisted the temptation to close the slightly cracked door. The foreboding feeling dissipated with the presence of sleep but lingered until fatigue consumed him once more. The entrance of his room remained slightly ajar as the silhouette of his so-called mother consumed the space with an ominous intent.

8

THE QUESTIONING

——

"Does there seem anything off to you about … you know?" Elliot asked Drew.

"Your social life? Absolutely."

"Drew."

"About what, Elliot?" the girl said with a tinge of annoyance in her voice.

"Mom?"

"Mhmm," Drew hummed trying to give as little to the conversation without blowing her younger brother off.

"I keep having dreams of her walking around the house at night."

"Look, her demeanor has been a little different lately, but, hello, she practically had a midlife crisis. Dad says that's what probably triggered the accident. She's getting older."

"She's forty."

"It's called menopause, bub," Drew said, with flawed conviction.

"I just don't see why that would make you want to put your head in an oven."

"Elliot, what are you even talking about? She's getting better. Besides, it was an **accident**. Sure, at first she refused to

come out of her room for a few days or just stared into space for a few minutes, but she's doing better especially after two months … you even said so yourself."

"Yeah, but … a few days ago I think I saw her staring into space again, and this time it wasn't just a dream. She just stood there in front of the fridge for a long time … not doing anything."

"I mean, that is what you usually do when you're looking for something to eat, Bub."

"No, I mean she wasn't really looking for food it was about three in the morning."

"Three in the morning? What were you doing up?"

"My throat was ticklish, so I went to get some water from the kitchen. I think she must've been confused."

"Or she might've had the late night munchies."

"She was just staring at a pie. It wasn't even baked."

Drew moved closer to her brother in the kitchen of their home and placed her hand on his forehead.

"Do you have a fever?" Drew asked as her brother swatted her hand away. "Just checking. You *did* say you had a ticklish throat."

"You're not my mom."

"Well, neither is Mom, according to you. I'm trying to help."

Just then, the two children heard a honk coming from the driveway. A few seconds had passed until a frantic Mr. Moore descended the U-shaped staircase, quickly grabbing lemon detox water from the kitchen just before being on his way to the dentistry.

"Kids, I know that I told you I would take you to school today, but I have an emergency root canal this morning."

"Can Mom take us to school?" Elliot asked Dad.

"Don't start that. Stasia is outside. Don't keep her waiting, son."

Elliot scoffed.

"I thought you said Mom was acting weird anyway. What's wrong with Stasia?" questioned Drew.

"Nothing."

"Have a wonderful day, children," voiced Mom from the staircase leading into the kitchen as she descended to the base of the smaller steps. Her arms crossed as she stood in a Victorian style nightgown. Both children stared in a catatonic state, surprised to see their mother awake and functioning at this time of day. An occurrence like this hadn't happened in months. Dad looked at his children's blank stares and creased his eyebrows.

"Ann! You're up?" their dad questioned, astonishment written on his face. He quickly jiggled the watch on his wrist and looked at the time, unable to dwell on her new stage of recovery.

"I have to go, but you take care of yourself today, honey. Also, there's a book club meeting at the Thibault's today; you should go to get yourself out of the house since you're up."

Mom just looked at Dad with a sweet smile that he met with a slight nod and grin.

"Okay, well, I'll be going. Kids, follow me out of the house and say goodbye to your mother."

"You're finally up," Elliot whispered to himself, shaking his head while exiting the house in a hurry.

"Bye," the two children said as they departed.

Elliot looked back to see his mother with the same grin staring at him as she leaned in the doorway of the kitchen leading into the foyer. He scuffled closer to his sister as they exited the chilly house and made their way into the driveway.

He had begun to feel a distance between him and his mother, much to his dismay. Elliot was always considered a momma's boy to all who knew him. In fact, he was the subject of bullying because of his close nature with his mother.

You're becoming too feminine. *Stop.* He'll never grow into a man if he continues to suckle her. *Stop it.* Look at how scrawny the boy is; it's because of that mother of his. *Stop!*

Those were all things he had heard much of in his short life by his mother's side. The comfort, which he once found in her eyes, had glazed over and was no longer there as he looked back at her while leaving the house. The peace that his mother ensured in such a cruel world was now replaced by solitude.

"Hey you two!" yelled Stasia. "Nice to see you all this morning."

"Hey what's up?" responded Drew.

"Nothing much," Stasia stated. Elliot whimpered as he slid deep into the backseat without noticing his sister looking at him in a concerned manner in the rear view mirror.

"Is this a cause for concern?" asked Stasia, noticing as well.

"Just a headache."

"Would you like an aspirin, Bub?" They both peered at her in unison as she turned around to face them in the backseat.

When did she start calling me Bub? Elliot thought.

"Are you allowed to give us drugs?" questioned Drew bluntly.

With a slight laugh and grin Stasia's gaze shifted between the two of them as they stared back at her with sincerity in their questioning faces.

"You two sure do have a way with words," she stated, shuffling through her purse to find the medicine. As Stasia did so, she managed to pull out two pills and laid them in her palm handing them to the boy. "Here it'll knock that headache out in no time with some water … and maybe don't tell any of the kids at school that I gave you 'drugs.'"

"Sure, whatever," interjected Drew. "Also, Stas, since we're keen on pet names now, I've been having cramps on and off for the past few weeks, and I think it's my period. Do you have anything for that?"

"Gross," retorts Elliot.

"Well, you only have a cycle once a month, but I guess cramps do come and go depending on the time frame. Do you have them now?"

"No."

"Then no. I do not need you two walking around school with a wonky liver. You have plenty of time to do that over the age of twenty-one."

Drew slumped back in her seat with a huff. "Whatever you say, *Mom*," she replied sarcastically.

8.1: THE QUESTIONING

> *Red is the preference of impetuous robust men and savage nations.*
> *No life, no love, just blood.*
> *Scheele's pigment poses fertility and harmonious abode.*
> *My own hummingbird has left me for the preposterous shades of virile vigor and temptation.*
> *I despise the scent of the rose. I despise the sight of rose.*
> *Tell me why do my hummingbirds prefer its blood? Why do they prefer its gore?*

Ann Moore made her way out of the house around noon. Much different from her bland costumes during her

previous secret outings, she dressed in a vibrant green dress with floral patterns; something about today was different. She felt a shift. She had only dared to publicly make her way past the mailbox for months. As she stood in the kitchen doorway, she thought that possibly her husband may have been right.

"Dress how you want to feel and dress in what you want to attract," he'd always say to her.

By costuming herself as her "best" version of Ann, she assumed the masquerade of feeling as she had for fifteen years. As a marionette in her own body, the feigned and unauthentic ways of life had become second nature. Noticing that both the family wagon and her husband had disappeared from the driveway only to leave Stasia's obnoxiously vibrant Volkswagen in front of the mailbox, she decided to walk. There was no bus stop in sight of the suburban hills, which prompted a stroll to the local bookstore. She knew that her presence would be a public spectacle, but with it only being noon, she garnered only a few peeking housemothers along the way.

The show has begun.

8.2 THE QUESTIONING

What is allowed within the home is responsible for ailments.

Keep her pure for its foundation may run cold.
A bell chimed. As Ann entered the bookstore, she observed two employees and a potential customer occupying its cozy, yet cluttered walls.

"Hi," the storekeeper sporting frazzled hair and oversized garments greeted.

"Hello."

"Your dress is quite the show stopper."

"I could say the same for you," Ann responded, eyeing the interesting choice of style that the blunt storekeeper fashioned.

The storekeeper gleamed a smile. "So, how can I help you? Let me guess. Fashion or sewing is your forté? Or am I just being entirely too assuming at first glance?"

At least they had the courtesy to recognize their assuming nature, unlike the rest of the censorious world.

"You're getting there ...," she said, peering around the store without moving an inch. "I would l like to know if you have any copies of *The Principles of Good Taste and Ornament*? It's a Victorian era text based on the principles of a good home and good life."

"Ahhh. Okay, well I could take you back to the classics for you to scan for hours on end, but I'm sure a lady of your stature has places to be and people to see."

"As they say, proper ladies and gentlemen are dressed conventionally and are well-behaved."

"Ha...I'm sure they do. I won't bore you with all of what I just said any further, so let me check our system quickly and, uh, make yourself at home."

The storekeeper swiftly moved behind the register to search for Ann's obscure text. While waiting, Ann's eyes observantly scanned the classic novels displayed near the front of the store. *Sense and Sensibility...Little Women...Emma.* She let her fingers glide across the novels pondering about their place in a context relevant to her own life.

"Excuse me, ma'am?"

"Yes."

"We have two copies in our lifestyle section if you would like me to show you."

"Of course."

She stealthily followed the storekeeper's motion, they made their way to the book hastily. The bookstore keeper carefully scanned the rows upon rows of books until stopping abruptly at a green book spine.

"Here it is," the keeper announced as they handed the thick book to Ann.

"You know, I'm actually surprised *we* had this. I would've thought that you'd find it in some nook or cranny in the library, but I guess there is always something somewhere out there for a specific crowd, even here."

"Yes, I reckon that is true."

"Okay, well, holler at me if you need anything else!"

Ann nodded understandingly and looked down to see the hardback cover of the dated book. She flipped through the pages brimmed with wallpapers samples recommended for household décor, chapters of popular recipes of the era, and principles of the Victorian womanhood; principles that she was willing to swear by. She made her way to the counter still flipping through the pages intently, not once looking up from the book's dated pages.

"Nice to see that you like it," said the book keeper as Ann remained consumed in the text.

"That'll be $13.75."

Without missing a beat, her eyes remained glued to the book as she whipped out a black credit card.

"Oof, cannot say that this store has ever witnessed one of these black cards … Mark Moore?"

Ann looked up slightly from her book and responded bluntly, "Charge it."

The keeper seemed slightly embarrassed by their invasive comment.

"No need to bag it, thank you."

"I figured...Well, you have a nice day, ma'am."

"I hope the day is as nice to you as it is to me," responded Ann.

9

THE OBLIGATION

———

As Ann walked out of the bookshop into the afternoon air, the sun illuminated her skin and a youthful vibrancy washed over the Scheele green and white dress. It was a beauty she often resented because it was evident that it would fade with time and that time was already ticking. Prior to her accident, it was evident that her beauty (and only means of self-identity beyond her value as a mother) had been dwindling.

She could read it in the expression of her husband becoming more and more disinterested in her romantically and more focused in her objectively. It was written in the way her counterparts would coin sly remarks embedded in microaggressions that weren't so micro and backhanded compliments.

"Oh, Ann, you look exhausted! Here, I have a new face mask you should try."

"Oh Ann, join me on this cleanse I discovered. You'll have that newlywed glow all over again."

"You know you are just so beautiful ... must be hard to keep up with these young ones around here."

"Given what your husband does, you must not need to work."

It was even the way her children exuded a slight tinge of embarrassment when she wanted to make herself look good because too good is too much.

But this day marked the first day in months that she had the courage to renew a part of herself. That morning, as her children and husband left for school, she had made sure to dress her best as she packed their lunches and sent them off. Despite her performative contemplating in regard to her husband's plea to join the suburban socialite realm once more, she knew where she would go, and who she would intend to cross paths with.

Her mind sometimes floated out of her body as she rambled on about the days she spent in repetition.

Wake up.

Walk toward the mirror.

Freshen up your face with face wash, toner, and moisturizer right in that order.

Robe, slippers, down the stairs and to the kitchen.

For Drew? Turkey on wheat with lettuce and tomato. Don't forget the green grapes and sun chips as a snack. You know she'll eat that prior to her actual lunch.

For Elliot. Sweet, sweet Elliot. Turkey on wheat as well, nothing more nothing less. Pretzels and juice on the side will suffice.

As a wife and mother, love should be shown for better or for worse. Prepare two notes written on napkins that read: "A sweet treat for my family to eat. xox Mother."

In addition, pack your treat with a hint of extra love: a slice of pie.

As alarms upon alarms sound around the house, resort to your position. They are up and they are awake. Your husband's office space adjacent to the bedroom is where you are to go prior to your family's wild descent down the stairs and out the door.

Your husband should never know that you hold the password to his desktop with all the files incriminating him of potential unfaithfulness. It is a wonder that he even realizes his "sick" wife is out and about unless it concerns him, so why would he ever know? In addition, has he seriously not learned to wipe his browser history after visiting adult sites and video chat rooms?

MissMicahMasochist must be a woman he visits quite often during his private time in the house.

Click. New message:

"Congratulations Seb2212 and funkybunchman for being this month's top contributors to the webcam there's more to come ..."

Yet, I am the clueless one.

This is okay because you couldn't care less. What you want is access to your hidden files. You would think being a wife, or as some may call laborer, for nearly fifteen years would earn yourself a gadget of your own. But no, a woman with a credit card and her own authority is just as hazardous as the internet. That type of woman shows her possibilities beyond the suburban hellscape established within this marriage. That type of woman is not okay.

How ironic for you, Mark.

Back to business. Locate your hidden file, which holds all your recipes. You have fifty minutes of peace to yourself, so hurry. A Cookbook for the Victorians is what it is to be titled. You've been working on your latest recipe, Vic's Apple Pie. You are sure that Stasia will like this one. You must get it right before passing it along to your apprentice.

Ingredients include 2 ½ cups of all-purpose flour, 1 tablespoon of sugar, ¾ teaspoon of salt, 16 tablespoons (2 sticks) chilled unsalted butter, cut into ½ inch pieces, 6 tablespoons

(or more) ice water, ½ cup sugar, ¼ cup light brown sugar, 2 tablespoons all-purpose flour, 2 tablespoons Victoria Taylor's Apple Pie Spice, 3 pounds of hard apples-peeled, cored, thinly slice, milk, additional sugar, apple pie spice and everything nice as well as a hint of arsenic. Preheat to 400 degrees stick your head in, jokingly of course, to check the heat and there you have the perfect apple pie. All done.

Just like that, there goes your fifty minutes of peace and serenity.

Here comes your honey, bustling about as your children follow.

You can hear the honks of a car outside as your husband hastily shuffles your kids out the door as they carry their bags with them. You stand in the entryway to the kitchen, your son uncomfortably staring back at you in disbelief of what he is still unsure he witnessed the night before. What a silly boy. You hope he enjoys his lunch.

A honk jerked Ann out of her train of thought, as she had been walking for several minutes. She managed to make her way back into her never-ending neighborhood of identically replicated homes when she turned her head at a driver letting down their window.

"…Stasia."

"Hi, Mrs. Moore. I'm surprised to see you outside."

"As many are these days," Ann said.

"Oh no, I did not mean it that way; I meant I'm surprised to see you walking at this hour and going about town without your car and all. Well, obviously, you can't really get places since I'm in your car, and your husband took the other one … you know my car is at your place, but I'm sure an antique Volkswagen isn't really your style AND I mean that in a good

way. Besides, you couldn't really drive that either since I have my keys too … I—"

"You're rambling."

"I am?" Stasia said. "Yeah, sorry. I guess I just got a little caught off guard, which is ironic since I'm the one basically tailing you in your own car as you're strolling through the neighborhood."

Ann continued to stroll on the sidewalk as Stasia slowly followed her in the car with her window rolled down.

"So, would you like to get in the car, Mrs. Moore? I can take you wherever you need? I was on my way back to check on you and see to the house anyway."

Ann stopped in her tracks as she clutched her book closely to her chest, prompting Stasia to halt the car to an immediate stop. She calmly entered the car's passenger seat at Stasia's request. As the two sat in silence for a few seconds, Stasia awkwardly decided to press on down the neighborhood street, assuming their destination.

"Your dress is so vibrant and beautiful, Mrs. Moore," the girl complimented enthusiastically in attempt to liven the awkward mood. "I mean the green really makes your eyes pop—"

"Ann."

"Pardon?"

"Call me Ann. Like I said before at the house, no need to call me Mrs. Moore. Everybody calls me that; you don't have to." Stasia softly smiled at Ann's assertion. It was as if she was slowly opening up to her.

"You know my middle name's Ann too."

"Is that so?" Ann responded, already aware.

"My dad said he thought of the name from an old friend. He was going to name me Rose, but it reminded him of the

last time he saw her, and it hurt too much to think of them that way. I guess he chose to honor her instead by giving me the name."

"Who was she?"

"I had the same thought when he told me that story. I mean, who is this woman who holds that much sentiment to my father that he names his own daughter after her? It's not my mother, if you're thinking that. I suppose she was an older neighbor he looked up to or something." Ann shed her rehearsed smile for a moment, looking away from the girl's direction.

Her own father claiming their last interaction pained him as much as it did she, yet selling her identity to a new bastard child was easy as can be.

"Hmm," Ann responded. "Are you close to him?"

"My father? Yes, I'd say so. He's my number one man since day one. He champions me so much it can get a bit unbearable sometimes, but what more can you ask for in a father, right?"

"I wouldn't know," Ann stated as silence settled the conversation. Stasia drove on, as she appropriately didn't want to push the awkwardness any further.

As Stasia came closer the cul-de-sac near the home, Ann continued to look out of the window before breaking the silence once more.

"I would like to go to Harlo Thibault's book club meeting."

"Not home first? If you need anything I can swing by."

"The Thibaults'," she asserted, still clinging onto the book in her lap. She turned her head to face her oblivious younger sister with a smile. Stasia faced her, returning a smirk.

"Sure."

10

THE BOOK CLUB

———

The cream-colored family car pulled into a new cul-de-sac just over the hedge from the Moores' own. Arriving at the Thibaults' home, Ann knew that just beyond the doors was a watering hole of mingling middle- to upper middle- class women, all flaunting the achievements of their husbands to make themselves feel better about taking the backseats to their own lives. Novel discussions were a thing of the past in this particular book club.

Stasia's assumption was that each meeting was a cover-up for devious gossip and judgment that all sane minds would want to rid themselves of rather than subject themselves to. Unbeknownst to the young twenty-something who possessed all the attributes that could crown her as a prodigy of sub-urban socialites, her mother's protection from the cruelty of judgment was no match for her father's sins, which eventually would follow her like a birthright.

"It might last longer if you take a picture," suggested Ann in a monotone voice, prompting Stasia to snap out of her trance.

"I was just wondering what the book club was like … I haven't formally been a part of one since college, which really

wasn't much of a book club more than it was an opportunity for English majors to get free food."

Ann smirked. "Why don't you join us?"

"Really? You don't think they'll mind?"

"What is there to mind?" she said with a fake gummy smile reminiscent of Mark's.

Stasia slightly returned a grin at the backhanded compliment, as she was unsure if it was supposed to ease her growing nerves or trash her confidence. The feeling of unsureness often absorbed the girl while being around Mrs. Moore, or "Ann," as the lady invited. She tightroped between the received feeling of interest and resentment. It was as if Ann served as a mentor but wanted to maintain a distance that confused Stasia. Maybe the financial and social comfort that fortified her world prior to her endeavor of independence was just met with the circumstances of the real world.

Ann swiftly exited the passenger's seat as she walked up the long sidewalk to the Thibaults' front door. She stopped midway to look back at Stasia still in the car, gazing at her movement.

"Are you not coming?" questioned Ann rhetorically.

"Oh! I'll park."

Ann never turned around as the girl quickly put the car in park and scurried behind her at the door. The two stood at the entrance for a few seconds in silence. Little did Stasia know that walking into the Thibault home was like walking into a lion's den, but at least the Thibaults had the luxury of calling those four walls a home compared to the Moores in the eyes of Ann.

"Aren't you going to ring the doorbell?"

Ann maintained her silence, and much to the girl's surprise, the door jilted open with an overenthusiastic Harlo welcoming the pair.

"Hiiiiiiiiiiiii! Mrs. Moore it's so nice to see you here. I was hoping you would come, but we weren't expecting you!" the woman voiced as she pulled Ann into the foyer by each shoulder.

The entire club of thirteen women stood like marble statues as they peered for a glimpse at the only lady they had known to stick her head in the oven, allegedly. Ann continued to clasp her book tightly in hand while Harlo seemingly held her for interrogation.

"Let me get a good look at you," Harlo said. "Your dress is immaculate. Who knew green could be as bold as black. Have you been working out?"

Ann continued to sport a rehearsed grin. The ladies stood and sat eerily still, remaining perplexed at the sight they were seeing.

"There's not much time to exercise when you're on bed rest," interjected Stasia. Ann could see the instant regret smeared on her face at her choice of words. Unbeknownst to her, it entertained Ann quite a bit.

As Harlo peered over her peer's shoulder she questioned to Stasia, "Who are you?"

"Sorry I'm—"

"She's my replacement," Ann said as she allowed a loud deafening cackle to exit her throat startling Harlo.

Harlo let out a small giggle in an attempt to provide a socially acceptable response. "Your what?" she managed to ask smiling uncomfortably. A delayed response ensued as Ann broke loose from the grip of Harlo Thibault.

Stasia, looking stunned at her assertion, still stood back at the doorframe of the door, while Ann slowly walked to the left of the entrance where the rest of the book club members were now mingling in a low tone, still eavesdropping nonetheless.

"You heard me, Mrs. Thibault," Ann said, "my replacement. Yours is instant takeout and after school tennis practice while mine is Stasia."

Harlo released the breath that she was holding and let out a hardy obnoxious laugh while Ann didn't miss a beat. "Oh, your nanny! You always did have a way with words."

"You're referring to me as if I'm dead," Ann turned to say to Harlo swiftly losing her sadistic smile she had just brandished.

"You know I didn't mean it like that! You've just been gone from the meetings for quite a while; we miss your jokes."

You didn't mean it this time, the last time, or the next. "Well, my humor and I aren't dead just yet."

"Stacie? Come, come!" demanded Harlo as she pulls the girl from the doorframe while shutting the front door.

"It's Stasia," Stasia trailed off while being dragged into the midday function.

"Everyone, look who I have!"

A chorus of curious and invasive ooo's and ahhh's came from the room.

"Now that everybody is here, let us all take a seat," announced Harlo.

As each lady slowly took their places on the various arrangement of sofas and day seats, Stasia found a place near the large window.

10.1: THE BOOK CLUB

"You'll find that this book club isn't much of a book club. Rather, it is more of a day club," said one woman to the girl. She returned a nod and listened intently to the conversation ensuing. "Today, we have Stacie joining us!"

A disingenuous chorus of "Hi Stacie" followed the announcement. Ann was sat at the front like a gleaming trophy on a mantel piece being admired by all.

"So, as you all know, we have completed the Alice Walker's *The Color Purple,* and today we vote on a new novel that we'll discuss over the course of this month. How did you all fare with the ending?" Harlo prompted the uninterested women who all fashioned some form of the same bland Banana Republic khaki pants and cream blouse combo.

"Nettie's return was so powerful," one woman quickly said. The room filled with nods and hums of agreement.

"I remember when my mother had me read that novel for the first time. The notion of 'womanism,' as Walker coins it, really sat with me when I think of a woman's place within society," interjected Stasia. "It's a shame how women are still pigeon-holed into subservient roles by men in this age. I mean Celie's characterization shows the competence a woman holds. Being a woman shouldn't mean being second, but being equal."

"Should she have received equitable treatment?" bluntly questioned Mrs. Moore.

"Excuse me?" Stasia responded directing her attention to Mrs. Moore.

"Should the story or, dare I say, the world, have met Celie's trials with equity rather than equality? You did say that women are equal to men, did you not?"

"Well, yes, they are, I mean *we* are," said Stasia. "Honestly, I believe that the story could have met her with something even better than equity now that you mention it. Justice is what was needed. Equity should only last for so long because it determines if we remain in an unjust world. As for equality, well, it is just that, equality. Despite the differences of oppressed peoples, in this case the women, it doesn't mean

that all is consistently fair or just. The women deserve the barriers of the world to be removed, but I guess the society was just not there yet, right?"

"I guess not," Ann said, eyes not leaving Stasia's for one moment.

It was as if a mass grumble enraptured the room as a groan of "rights" rather than sparks of debate or engaging conversation dwindled the momentum of the thought.

"What's all this talk of oppression?" Nadine Frank, the head of the school's PTA and self-proclaimed woman poster mother of Pulaski County sharply stated. "*I* for one do not feel oppressed. I mean it is my right to be a housewife if I want. I think that it's ridiculous that the women in this book insisted on anything more than what they got. What more do you need when you get to sit at home and see to children, not go to war and slave all day."

"It's almost as if you didn't read the book at all, Nadine," Ann said.

"I didn't realize she could read," the woman, Andy Lynn, slyly remarked as her statement was met with the laughter of the other women and Mrs. Nadine's daggered eyes bored into the side of her face.

"Maybe it would serve you well to prioritize your own husband over this club if we are on the topic of hobbies and devotion."

"Ladies! Ladies!" Harlo interjected, waving her hands around attempting to gain control of the crowd again.

"My only gripe is that I can't get new flooring without my husband complaining about it," another stated prompting the ladies to laugh.

"I think you are missing the point and ignoring an entire type of woman and an entire type of experience..." interjected

Stasia once more. Her attempts to get anywhere worthwhile with the conversation were just as helpless as Mrs. Thibault's attempt to gain control.

Stasia wondered where Mrs. Moore fit into this entire setting. Although she was fairly quaint and quiet, she had a way about her words when she chose to speak. The women around her seemed rehearsed in a way that was nearly too cheesy or exhausting to tolerate, but Ann—she was rehearsed in a way that didn't control her, but she controlled it. She upheld all the duties of a wife, mother, and woman, but to hear her speak was as if she slightly mirrored Stasia herself.

"Speaking of returns, how have you been, Mrs. Moore?" asked another curious housewife.

"Fine."

The entire room grew silent once more for a few seconds at the curt response.

"Thank you," Ann offered at the response to the silence.

"We mean ... how have you *really* been?" another questioned.

"I have a novel that I elect as this month's read," said Ann.

"Great! Oh! That's great—finally right back on track," remarked Mrs. Thibault.

The rest of the room rolled their eyes and quietly huffed at the failed attempt to extract details about Mrs. Moore's summer fiasco. The entire unwritten motto of the club was to reveal everyone else's dirty laundry while keeping one's own in check. For Mrs. Moore, however, it was to not reveal too much of yourself yet be entertaining, a trade she had perfected.

"What's the title?" continued Harlo.

"*The Principles of Good Taste and Ornament.* It is a classic novel," stated Mrs. Moore.

"Oh boo. You might as well hit me over the head with *Wuthering Heights*," whined Nadine.

"Oh, I'll gladly oblige to hitting you over the head with anything," grumbled the same woman who challenged Nadine once before.

"What is it about?"

"It's a guide."

All the women pondered at the obscure answer and looked back to Mrs. Thibault.

"Interesting. Any other suggestions?" Nadine interjected unphased by Ann's proclamation.

"I elect *The Bell Jar.*"

"All in favor?"

"Sure," they all shrugged as they couldn't care less.

Shattering the idealist vision of a unified group of different women, it was as if the book club had grown accustomed to their own ignorance and ignoring other women, even those directly in front of them.

Ann and Stasia prepared to leave the congregation as soon as it was decided.

"You're leaving so soon?" followed Harlo.

"We're busy," said Ann.

"Oh, I hope they didn't anger you. You know they don't mean harm."

"Anger is not my forté, it's theatricality."

"I'm serious," Mrs. Thibault sincerely said, stopping Ann for a moment as she grabbed her arm. "I hope all is well. I know we may not be close friends, but our husbands are. It can get stressful at times, hell, I even think about it sometimes. Listen, if you want to come by anytime and talk when the guys aren't here or the other book club members, come on by. It's a shame that I didn't reach out earlier."

"I appreciate it," Ann said with a blank face as she turned back around and got in the passenger seat of the car.

Mrs. Thibault watched from the walkway leading to her home as the car slowly drove off down the street. The woman seemed to hold an eerie grin, aimed at Ann. The car ride reverted to silence, much like their previous car ride, until the curiosity of Stasia nearly bit her tongue off.

"Doesn't that ever bother you? How they just manhandle your conversations?" questioned Stasia.

"Interesting choice of words."

"I mean …"

"One thing I suggest you learn is knowing what you mean and meaning what you say."

"… Okay."

Stasia wondered whether she should continue the conversation with the unwelcomeness in Ann's voice. She couldn't help herself because no matter how intimidating Ann seemed to be, she was hypnotized by her aura.

Stasia mustered up the courage to continue. "What I mean is that they just run over you with their vapidness. I mean you're so mystifying in a good way, and no one seems to appreciate it. I don't mean to sound strange or like I'm stalking you. It's just an observation."

"That makes one of us," mumbled Ann as faint as a whisper. "They may be vapid at times, but it's something you'll learn to put up with if it means the shrewd nature of the world can escape me for just a moment."

My little hummingbird will leave this shrewd
world with heart and good intention.
I will send her to another dimension.

11

THE FEELING

——

It swallows the body whole. It swallows its last glimpse of the light of day.

"My stomach hurts," explained Elliot.

"Does that mean you're not going to eat your sandwich?" questioned his only friend Nikki.

"No."

"Cool."

The school cafeteria, or better known by faculty as the nutrition center, bustled with young children's voices, school lunch trays slamming on tabletops, and small sneakers beating the floor beneath them. Nikki took the boy's dinosaur lunch box and grabbed the neatly cut sandwich.

"You should get rid of this thing by the way," Nikki said. "We're going to sixth grade next year, and it's a bit sissy."

"You're a bit sissy."

"Touché ... Hey what about that slice of pie?"

"Want to share?"

"Sure," the boy immediately agreed.

The two began to rip apart the apple pie and shove the slice into their mouths.

"What does your nanny put in this stuff? It tastes better than Mickey D's," asked Nikki.

"My mom made it. It was really weird, she was up at like three in the morning making pie, I think."

"What do you mean you think? Either she was or she wasn't."

"Well, I got up to get some water at night because I had a headache and my stomach sort of hurt too..."

"My mom says that's what happens when you skip meals," Nikki voiced as he stuffed the turkey on wheat in his mouth.

"I went downstairs and my mom was there."

"Not to sound mean or anything, but my parents said something about her shoving her head in the microwave or something. What's her deal?"

"Are you going to listen?"

"Are you going to eat those pretzels?" Nikki asked, salivating at the sight of them.

"Here," Elliot slid the packet over to his friend, his appetite immediately becoing even more curbed as the remnants of the sweet treat covered his mouth.

"She was just standing there not moving, staring at the open fridge ... it freaked me out."

"Maybe she had night cravings. I have it all the time, only thing is my mom hides all the snacks in the house at night. You ever heard of fatphobia?"

"She turned around and I swear she must've known I was hiding behind the wall."

"I don't think you can hide Good Bars behind walls unless she has booby traps in the house."

"She was gone when I looked back again, but I was so scared, I just went back upstairs. I felt pretty weird the whole night."

"I wonder if she just hides them in the top cabinet. I mean I can climb, but she would be so mad if I busted my butt at two in the morning. I heard a talk show talking about fat-phobia, and I think she's doing it to me. Do you think she's doing that?"

"Nikki, I'm in fifth grade, of course I don't know what fatphobia is."

"But you know everything else. You're too smart for your own good; that's why you only have me as a friend."

"My sister says I only have you as a friend because I'm bad at speaking to others."

"It could be both. You've got a port wine stain too."

Elliot looked at his friend with slight offense. "But I think it's cool though," exclaimed Nikki in his defense.

Elliot pulled out the napkin note reading, "A sweet treat for my family to eat. xox Mother."

"I mean I guess she's okay," responded Elliot. "Maybe I was just having a nightmare because of my headaches. I read that you can get hallucinations from migraines, but those are more like colors in the sky caused by brain tumors."

"You think you have a brain tumor?"

"Maybe I should go to the nurse."

"She just gives you ginger ale and makes you lie down for thirty minutes. I go there whenever I need a nap. Maybe you should wait until after recess."

"Yeah, you're right."

The whistle sounded for recess. With that, the two boys cleaned up their scraps and headed outside.

11.1 THE FEELING

Back at home, Drew had arrived early, not quite remembering how she got back.

"Mom? I'm home a little early. I was feeling a bit queasy after lunch ... Mom?"

Drew shrugged, headed to the kitchen for a cup of iced water, and dropped her bag on the kitchen floor. As she downed two cups, a slight noise from upstairs caught her attention.

"Stasia?" It sounded as if something had fallen into one of the sinks upstairs. Her mom had to be home. To her knowledge, she hadn't left the house in months, or maybe Stasia had dropped by early too to keep the house in place as her presence began to overshadow her mother's looming soul.

Walking up the stairs, the curious girl couldn't help but to think about writing this into her journal. Her mother once loved to write, which sparked Drew's own interest, but with her motherly duties and now the accident, it was as if the only excitement they had potential of sharing together was stripped away.

She often wondered who her mother once was before being a mother, and who she would be after motherhood.

What girl obsessed over who she would be after motherhood when she didn't even know who she was beforehand? Is this the legacy she left behind before ever leaving, or was it symptomatic of her household?

Either way, it didn't quite matter at that very moment, but it most definitely haunted her mind from time to time.

After walking halfway up the stairs, the adolescent heard another distinct "clink" come from the upstairs bathroom. This time she was sure it came from her mother's room. Slowly ascending the rest of the staircase, she made her way down

the hall and into the room, opening the master bedroom door with great care to ensure it did not creak. The closer she got to the source of the noise, the farther away she felt she needed to be. Drew's gut wrenched as a strong waft of garlic met her nostrils, much to her disgust. The girl inched across the master bedroom belonging to her parents, making sure to tiptoe as silently as possible toward the bathroom. The bathroom door being ajar fed her curiosity.

She halted and pressed her face to the slight opening of the door that separated her from the bathroom. Her mother's hunched bare back slightly met her eye. Blood dripping in the gleaming white sink. The sun rays from the window shown on the pocketknife, which Drew had previously heard drop in the sink twice. Not yet able to see her mother's face, she was perplexed by the strange nature of her current being, the teenage girl's eyes slowly met the markings on her mother's body she could see reflecting in the mirror.

A small rose was carved just above her hip. Drew's eyes widened. Her gaze traveled up her body a bit more where what seemed to be the outline of a kitten was carved just above her mom's collar bone. Red still bled into the sink and onto her hands. Drew stifled a gasp as she stepped back slightly only to make the wooden floor creak.

Mom's attention had been caught. Her gaze caught Drew's in the mirror as she fashioned a bone-chilling grin. Her mother failed to blink and her hands fell to show the blood dripping down her body. Her gums were on full display and her eyes were slightly bloodshot. Drew stood at the door, stunned. She remained in a catatonic state until her mother slammed her hands on the bathroom counter.

Drew could not manage her balance as her knees buckled beneath her. The girl's jaw dropped out of fear of what

she was witnessing but beyond her control it continued to widen in an inhuman fashion. A tar-like blood substance began to pool from her mouth as she kneeled frozen on the ground. Her mother jolted at the thud of Drew's knees meeting the wooden floor. Mother's sinister gaze met with Drew's. The older woman could see tears pooling down from her daughter's frozen face. As she cried, Drew could see the sick amusement written on her mother's forming grin. Her mother was trying to consume her. She could not stop it.

11.2 THE FEELING

Drew screeched, fidgeting from her sleep as tears streamed down her cheek. A few yards from Elliot's primary school, Drew was battling to stay awake in class. She looked up to see her teacher's ruler against her desk.

"You can join us at any time, Miss Moore. I get paid either way."

"I'm so sorry, I just had a nightmare."

"We can see that. Spruce up or it'll be a pop quiz waking you up next time, understood?"

"Yes, sir."

11.3 THE FEELING

Curiosity must kill the cat before the cat kills it.

By the time the school day ended, Stasia had already arrived with the family's cream-colored wagon. Much to the surprise

of the children, she was earlier than usual, as the car was parked rather than waiting in the carpool line.

Elliot, who was always picked up first walked up to the car, immediately made his way to the back seat and shuffled in. Looking out the window, he was too exhausted to talk because the boy had decided to skip lunch to relieve his bothered stomach, which seemed to make matters much worse.

"Why the long face? ... Bub?"

Elliot's eyes immediately shot up to the rear view mirror to meet Mom's eyes.

"What do those movies say? You look like you've seen a ghost or something."

Elliot's eyes widened like saucers as he saw his mother in the driver's seat.

"Mom ..."

"Son. How was your day?"

"It was fine. I mean, it was normal until now."

"That's a bit rude, son. You used to be so sweet."

"Where's Stasia?"

"You don't seem too enthusiastic about seeing me. Have you forgotten your mom already?"

"No, I'm just used to Stasia picking us up."

"Stasia isn't here. I got rid of her."

Elliot did not dare move at his mother's abrupt assertion. He was completely incapable of figuring if she was kidding or serious in her statement.

11.4 THE FEELING

Mrs. Moore slowly entered the carpool lane and out of the primary school lot. She drove down the street to her daughter's

school. As the car pulled into the lot, they inched closer to Drew. The girl jumped off the ledge she was sitting on while waiting for her ride. She jogged to the car with her bag in hand. Opening the car door with the same swiftness of her brother, she entered the vehicle to the immediate astonishment of seeing her mother in the driver's seat.

"Surprise," smiled Mrs. Moore.

"Where's Stasia?" questioned Drew.

"I got rid of her for the time being."

Drew met her mother's statement with silence.

"How was your day?" questioned Mrs. Moore.

"Which one of us?"

"Both of you, I have two children, don't I?"

A slightly confused Drew peered over at Elliot as he visibly seemed to cower in his own body. Mom had seemed sluggish and out of whack all these months only to return as if nothing had occurred. Her looming presence made them both uneasy, and it did not help much that it was met with dreams or premonitions of horrid occurrences. Drew thought maybe both she and Elliot had overactive imaginations. They must have she thought, maybe it's the flu, but who were they to tell this to. Their father was more often at work and was too self-involved with proving his ever-fluctuating bravado to soothe his own confidence. As for mom, she was an enigma. Maybe Stasia could help if only they knew where she was.

"It was fine, I guess. The usual," said Drew

"Any homework?" Mom questioned as she peered into the backseat through the rearview.

"Mom?"

"Yes, honey?

"Is it safe for you to be driving?"

The car jerked to a quick stop at a red light nearing their neighborhood—the same red light where the two children had nearly escaped a collision with the doe weeks earlier.

"Of course. Why wouldn't it be?" she grinned in her shining green dress.

The car remained silent until the light turned from red to green once more. The car's gears were again set into motion as they turned into the massive neighborhood.

As they inched closer to their driveway at the end of the cul-de-sac, Drew couldn't help but to stare holes into the back of her mom's head, much like her brother. Drew attempted to find the markings she had dreamt of in class but was met with no luck as the Schille green dress and cream cardigan covered any bareness of her body.

Exiting the car, the two children slowly shuffled out, grabbing their bags. Their hearts thumped at every step they took closer to the entrance of the house.

11.5 THE FEELING

Elliot opened the front door to his relief of nothing. A strong smell of sweetness engulfed the halls of the house.

"You go," motioned Elliot.

"No you," forcefully whispered his older sister.

Choosing to follow the scent they walked slowly toward the kitchen.

What could she have made for us this time?

Why does everything seem slightly off?

Are we in our right states of mind?

Elliot pondered numerous thoughts until he and his sister found themselves in the entrance way of the kitchen.

Bending down in front of the oven was a still lady. Their mom trapped them in the entrance way as she stood behind with palms resting on each child's shoulder. As his heart skipped a beat, the woman stood up from the oven with freshly baked delicacies. It was Stasia.

"Hey guys! Cookies? Your mother taught me how to make them from scratch."

A slight wave of relief washed over the two, but a foreboding mood was inescapable with each smile they saw their mom fashion.

12

THE DISINGENUOUS

Stasia had been spending quite a bit of time with Mrs. Moore after their book club event. It had occurred to the younger woman that it had been quite a while since she had a friend like her. Sure, her roommates were there, but they lacked the mystifying sophistication Ann held. The reverence she possessed for her may have been one-sided, but she failed to rid herself of it.

Stasia pondered if it was just the desire to have what Ann possessed or the longing for something she had always missed.

She did, however, pity her, as all of Ann's relations seemed as shallow as a kiddy pool. Possibly, it was all the time she spent around the woman, but why wasn't she mystified by the rest of the family as she had been by the mother? Could have been the way in which she remained entertaining without revealing much of herself or any at all?

It was as if Stasia was all too familiar with Ann but also knew nothing at all. That was what baffled her the most. It was the way Ann Moore intended it to be.

Whether it had been due to the naivete or sheltered life, Stasia failed to realize she had a shadow herself. The familiarity she recognized in Ann was an ever-increasing imitation.

12.1 THE DISINGENUOUS

For Ann Moore, their relationship was anything but one-sided, as Stasia may have seen it. Rather, it was an instance of communalism in intention and parasitism in action.

Reclaiming the life her little sister had stolen was a birthright. Her name, her father, her wealth, and her home were a lifestyle she spent her entire being attempting to replicate … and she did at a cost.

Playing by the rules of the patriarchy, she became the woman she thought her father left her and her mother for. Bowing to prescriptions, she became the wife her husband initially loved her as and eventually will leave her for not being. By complying, she became the housewife she thought every neighbor was looking for.

Through complacency, she became the mother she looked for when her own decayed under the pressure built relying on a man who told her not to worry, despite his ill intention to leave her in the dust.

The identity of her employer and the woman Stasia revered was blurred by illusion, yet Ann seemed to thrive in the disillusionment. It was everything she needed to acquire what was rightfully hers, the identity of Stasia Ann Pritchard.

12.2 THE DISINGENUOUS

Who is the marauder's apprentice?
Please call them once you read this.

"Hey, Mom! Dad! I brought you all some more flowers!" shouted Stasia into an empty foyer. The walls were lined with

lively photographs of family portraits juxtaposing those that hung dully in the Moore house. Years of birthdays, milestones and still memories reflected the home that the Pritchards had built. Stasia waited for a response as footsteps from a back room could be heard coming closer toward the living room where she stood.

"My, sweet pea! How many times do we have to tell you not to bring those roses!" voiced Stasia's petite mother. She fashioned a short and chic haircut and a casual yet vibrant skirt and blouse combination that exuded the confidence of someone much more youthful.

"Your centerpiece wouldn't be complete without them."

"You always know how to make this house feel like a home," Stasia's mother warmly smiled at her. The woman took the bouquet of roses in her hand and immediately placed them in an empty vase sitting in the middle of the living room's decorative table. She debated placing them on the mantel piece just next to Stasia or by her husband's many awards and heartwarming family photos, only to decide the deviation from her home's normal décor was too out of character.

"My little Ann!" her father called embracing her.

"No one calls me that besides you, Dad. Everybody calls me Stasia, the name you gave me. Remember?" she replied teasingly.

"Ah, yes, how can I forget, but Ann is just as much as your name as Stasia and Pritchard are. It's a title that represents my legacy!"

"You're right. You must uphold you father's legacy of truth politics if you ever intend to be a lawyer like him," her mother joked.

"There's no need for that, trust me."

"I agree. You are smart, bright, and beautiful, but there really is no need for you to become a lawyer whatsoever. Matter of fact, why don't you quit that other silly old job and let your mother and I get you a nicer place without roommates."

"I tell her all the time that I don't know why she insists on struggling when we are comfortable enough to care for her."

"Mom, if I wanted that I would just marry a carbon copy of Dad—"

"Sounds good to me," her father teased with a gleaming smile as he sat down on the sofa making himself comfortable.

"...Which sounds disturbing enough as is," Stasia continued. "I want to find my own way in this world, make my own life, make my own money and be sufficient by myself."

"And you think that will be achieved by struggling to pay rent and working for that family?" asked her father with a slightly stern look on his face.

"Who *are* those people?" her mother questioned.

"Their last name is Moore. The husband's a dentist, and interestingly enough, the wife's name is Ann."

Her father paused with a nod. He hesitated at the thought of inquiring about this woman named Ann, but ultimately did not push further to know much more.

"Hmm," her mother hummed, "That's a nice name."

"She actually made this skirt for me."

"I was just about to mention how strikingly green it was. She must have quite a talent."

"Yeah, she has more time on her hands now that I'm helping out. She's teaching me how to bake and sew."

"Maybe this job isn't all too bad if she's teaching you how to be a good wife," her father chimed in.

"Now it won't be too difficult to find yourself a good husband with lots of money just like your father!" Stasia's dad referred to himself. The young woman let out a strained laugh.

If it weren't for her birth certificate and DNA, she could have sworn she belonged to another family. She constantly fought with the homemaking tradition of the household when it came to being independent, but it also felt as if she were purposely rebelling to get back at her parents or shift the status quo. It was draining enough to be a young twenty-something, not yet aware of her own identity on top of what identity everyone else prescribed to her. The set of rules she lived by her entire life was dictated by men or women influenced by the proximity of man's rule. Maybe she liked Ann so much because she could recognize that silent struggle, of which she too was becoming familiar with.

"When do you go back?" questioned her mother.

"Ah, tomorrow. I just came over today since I hadn't seen you all in a few weeks and I'm sort of lonely at home. The girls went on a road trip to the Casino for the weekend."

"Those girls are such an interesting crowd."

"Mom, just because they aren't like you doesn't mean they're bad."

"Well, I didn't say that," the woman voiced as she neatly crossed her legs on the couch, sitting down next to her husband.

"Yes, but you implied it."

"Stay here with your mother and me for the night. You won't have to buy dinner and besides, we miss our string bean."

Stasia hesitated for a second, contemplating whether she should get back to her empty apartment or not. "I guess I could. I am a little hungry, and I doubt there's anything in the fridge back home other than yogurt and expired fruit."

"Great. Let's go eat in the kitchen!"

13

THE VISIT

—

The dark figure whose car was parked on the same end of the Pritchards' street a few weeks before started its engine and exited the neighborhood as the silhouettes of the family moved from one room to another. Stasia had spent a much longer time during this visit than before. Driving down the street, the figure decided to pull into the store that Stasia stopped by earlier to purchase flowers. The person exited the now-parked car and walked in, scanning the store for equally vibrant roses. The person fashioned large dark sunglasses and a beautifully patterned ascot tied neatly around their head.

Walking up to the clerk with the bouquet in one hand and money in the other, they put the currency on the counter, not waiting for the total after tax.

"Hey lady, there's no banquet in here."

The woman remained silent.

"I don't reckon you have a boyfriend, do you?" the clerk giggled at his own assumption.

She continued her silence.

"You must be one of a kind. Not many females have the decency to dress their worth anymore."

The woman looked up with the dark glasses and ascot still obscuring her face.

"Keep the receipt," she bluntly stated as she took the change and swiftly walked out the door.

She entered the car and slammed the door behind her, giving a glare into the store window where she could still see the view of the clerk's side profile. There was a slight tinge of disgust written across his cheeky face at the smell of garlic. The woman could not help but to fashion a tiny grin at the sight. She drove out of the parking lot with a specific destination in mind. After about half an hour of driving, she pulled into a classy apartment complex punching in the four-digit entrance code. If it were up to any other resident, she seemed as if she belonged there. The ominous woman stayed seated in her parked car for about ten minutes, looking up at the same apartment before walking into the building's lobby and over to the receptionist.

"Hi," the lady said with a sweet and soothing voice as she removed her ascot.

"Hello," responded the receptionist, slightly looking up from a glowing computer screen that occupied her attention, "How may I help you, ma'am?"

"Well, I'm trying to get into my daughter's apartment, but I can't seem to find the spare key she gave me. Her birthday is soon and she'll be coming back from a weekend trip with her friends for a surprise get-together we all planned."

"Okay..."

"I have a few more things I have to set up before she gets back if you don't mind," she stated with agency while motioning to the bouquet of roses in her hand.

"Well, we don't really open apartment doors for strangers like that, ma'am..."

"I get it, but I'm her mother. She has me as her emergency contact, right? Lana Pritchard. 501-555-6286? Right? That's me. Her apartment number is 2503. Micah and Penny are her roommates, they're quite the characters."

"... I ... yeah, I think I've seen those two before. It does say here in the system that you are the emergency contact too."

"If you insist, we could call her to verify my legitimacy," the lady said fashioning a smirk.

"There's no need. Besides, I don't want to ruin your surprise. Just one moment, I'll go get the keys."

The woman was now left standing there observing the architecture of Stasia's apartment lobby. Just as she took a few steps in the direction of the mirror, the receptionist returned, brandishing a large ring of keys. She turned around to take one last glimpse in the mirror before taking off her sunglasses and placing them in her small purse. She looked vibrant, more youthful, and a little more like the young thing that Stasia was. She was Ann.

"I don't mean to sound rude, but you seem more like a sister than a mother," remarked the receptionist.

"I get that a lot," Ann lied.

As the two walked toward the elevator that would take them up to the twenty-fifth floor, Ann turned to the woman with a slight grin, "It's so nice of you to help."

"It's my job. It's so nice of you to plan all of this. My mom and dad aren't all that creative when it comes to my personal life."

"That makes two of us," Ann responded, looking straight ahead as the elevator opened on the twenty-fifth floor. Following the receptionist to the apartment, they scanned an electronic key then used the manual key to open it.

"There you go, ma'am. Let me know if you need anything else."

"Sure."

"Oh and do you know how long you intend to be here? I can't let you stay the night without prior permission."

"Not too long. I'll be gone soon."

"Okay, well, good luck!" Ann nodded as the receptionist left, and she closed the door behind her. Walking into the dark apartment illuminated only by the moonlight, she looked around. Her fingers glided across the chic coffee table in the living room. A few lookbooks and magazines scattered the surface. She swiftly moved along to the kitchen where she saw various packets of passionfruit tea.

Opening the fridge, she saw various overpriced name brand water bottles and lots of yogurt. Temporarily bathing in her invasiveness, she quit her glancing and sleuthed for what she came for: Stasia's room. She looked directly down the hallway to see one door at its very end. Ann began to walk straight to it and paused just before entering. Each woman had a way of observing the other.

13.1 THE VISIT

For Stasia, her disposition regarding Ann Moore was more of an intrigue for a beautiful lady who reached the brink of psychosis. She was like a Russian doll, each layer embodying class, talent, and intelligence, but to the naked eye, she was a carbon copy of every other housewife. Stasia knew that not to be true. She swore she could see an aura reflecting from her vibrant green dresses.

To Ann, Stasia was no more than a biological half-sister, a thief, and the catalyst to her mental downfall. She was the reason her father left and the reason her mother crumbled. She was the embodiment of the patriarchy working against her, even though she herself had no clue. Ann resented Stasia for her existence, and because of that, she would now become a new identity out of her internal hell. Reaching for the door handle, Ann let the door fling open.

A pink quilt comforter was sprawled across Stasia's neatly made bed. Dozens of pillows accompanied the weighted quilt that lay on top. Scanning the spacious room, she saw dozens of novels above her white wooden vanity. Few cosmetics took up space on the table positioned on the opposite side of her room. Ann took one step in and immediately retracted. It was better to take her shoes off in such a neat living space. She slipped off her modest white sandals and held them.

Stepping through the room's door once more, her feet were met with the familiarity of coldness that came from the wood surface. Oddly enough, the normality of the frigidness on her toes was the closest she knew she would get to the warmth of a home. What she observed in the space was artificial comfort. Dozens of pillows, books and journals did not make up for the loneliness it reflected.

How did she feel lonely when everything she should ever want in her life is in her hands? A family... a real family, a home, and a foundation of independence she so overtly pined for? I guess one could say the same about me, thought Ann. But it was different for her. The void she was attempting to fill was all that the world had taken from her, and the vices of the world were represented by Stasia's ungratefulness for what she had. In that case, the switch was only rational as much as it was a matter of time.

"We are sisters, right?" Ann echoed in the empty room as she walked barefoot toward the closet.

She opened the door to the vastness of the walk-in closet as shoes for different occasions lined one side of the wall. The number was modest, but the selections displayed vigor. She began to see remnants of her old self in that closet and the new identity she was set to assume.

The selection of shoes included plain sneakers, clunky boots, and youthful platforms. Ah, a classic pair of black heels. *Red bottoms* she thought ... *wouldn't expect anything less.* Black heels are only good for two things, a metamorphosis and a funeral, and in this case, Ann would need them for both. Slipping her feet into the heels, she had no doubt they would fit. She had already known Stasia's measurements from all the oversharing she had regurgitated onto the internet.

Shoe size: Adult 7

Birth sign: Pisces

Birthmarks: One circular shaped mark on the wrist

Tattoos: Two; collarbone and waist

Wants: A corgi, free healthcare, and to adopt in the future.

No worries, she'll have a couple she could call her own soon enough. Her feet slid into the heels more gracefully than Cinderella's ever could in a glass slipper. She sat her white homey sandals down in the place of the shiny black shoes that now accompanied her feet. Her sandals served as both a housewarming present and a parting gift. There absolutely was no place like home, and she would be sure to meet with it soon ... both of them.

"They'll suit you well," Ann voiced.

She walked out of the closet and shut the door behind her. She proceeded to the small bedside table where a laptop lay. She was surprised Stasia had so much trust in the world

not to set up a simple password. A fatal flaw was something that was necessary for this transition to happen in Ann's eyes, but for her to be so stupid and trusting is what she deserved. It was necessary to survive in a man's world.

After all, Ann had taken on a persona that abides by the unspoken rules and regulations of womanhood and properness. Every woman who lives in subservience adopts some form of that philosophy somehow. It's a race, always, against your husband's machismo, your male counterparts, and if that is not so, it will be against your sisters of the world.

"Be fair, be kind," Ann recited as Stasia's computer background illuminated her face in the darkness of the room. *What a condescending load of shit.*

> *To be passive is to be only in proximity to patriarchy.*
> *Mannerable young souls will obey and unmannerable ladies will triumph.*

Click: Messages
I love you too mom! Will be there soon. 5:38 p.m.
Click: Notes

OATMEAL COOKIES!
- 1 and 1/2 cups (190g) all-purpose flour
- 1 teaspoon ground cinnamon
- 1 teaspoon baking soda
- 1 teaspoon salt
- 1 cup (2 sticks) unsalted butter, softened to room temperature
- 1 cup packed light or dark brown sugar

- 1/2 cup granulated sugar
- 2 large eggs, at room temp
- 1 Tablespoon of dark molasses
- 2 teaspoons pure vanilla extract
- 3 cups old-fashioned whole rolled oats
- 1 and 3/4 cups semi-sweet chocolate chips (Mrs. Moore's favorite)

Click: Documents
Resume ... Grad school applications ... junk ... junk
"I'll be damned," Ann said to herself.

For a girl who spends so much time oversharing and projecting her feelings to strangers, it's a wonder that she has absolutely no incriminating documents. Flipping the laptop closed carelessly, she huffed in annoyance. She took her time carefully prowling around the space once more, paying close attention to the perfumes, small collection of jewelry and, ah, journals. Stasia perused the color-coded books as she could see that one journal logged embarrassing encounters, the other odd, another for moments close to the heart, and another for despicable instances. It was as if she recorded her life in vignettes—something Ann wished she could do.

Though it was evident Ann lacked the ability to compartmentalize her life, she compartmentalized her emotion instead. To her, life was one long begrudged experience that went on and on. For Stasia, she could separate the good from the bad and ugly while still stopping to appreciate it all as individual lessons. Ann acknowledged that was what made them different. She would never be able to replicate the quality, but she would be damned if she didn't attempt to mimic it.

Ann opened a small baby pink journal and marveled at the loaded information about Stasia's "almosts" and sudden

brushes of love at first and only sight. Ann cruised her fingers along the page, orating each sentence like she imagined Stasia would in her sweet and spunky voice.

Visiting Aunt Niecey was great, but going back to that house reminded me of how her living room smelled of peppermints and old chicken potpies. Is that even a valid smell? It doesn't matter. Speaking of peppermints, I got on the tram to get Niecey's favorite peppermint patties before leaving town ... can you believe she sent me on the tram? What's more absurd than a city still having downtown trams? Your great aunt's making you take one to get her peppermint patties.

Her sister had apparently gotten her sense of humor from her mother's side of the family.

"Why did the father cross the road? To get to the other side where he belongs," Ann voiced to herself. She had a keen taste for morbid humor.

I got off the tram and saw the most beautiful man I've ever spotted in my life. You know when you hear stories from older couples about love at first sight? Well, that had to be it.

How immature, Ann thought to herself. It was hard for her to imagine priming her new image into that of an immature young woman, but it was a luxury she never once had. It was something she was never destined for until now. Ann continued to flip through the pink journal.

Dr. Moore sort of freaks me out. I mean he is a handsome man, but he's a bit inappropriate with his staring. I wonder if Mrs. Moore cares enough to even stop him, but in all honesty, what does she know. She's always locked in that room she calls a tower. Anyway, he's pretty handsome, nonetheless.

"Hmph," Ann whispered to herself while looking down at the confession. She couldn't say she was surprised or hurt at this point.

She contemplated tossing the journal down in a manner just as careless as the girl's thoughts, but instead placed it neatly back into its position on the shelf, giving the illusion that no peace was disturbed. Like father, like daughters, right? She then proceeded to pick up the orange journal labeled "Odd" and began flipping through it.

I'm not too sure I'm feeling like myself lately. It feels like something's missing or looming, like it has always been there and has never gone away all at once. I'm just a bit worried that people might notice there's something off about me lately. It could just be the recipes I've been making. It seems like I can't get that specific kick that Mrs. Moore has in her cakes and pies. I don't know how she does it in that tiny dress; it snatches her entire waist away. It is quite beautiful on her though. A woman who can manage bouncing back into her beauty while simultaneously doing things like that is a woman worthwhile.

Ann thought that Stasia was already beginning to sound like her old self ... Ann's old self. Ann was also ecstatic about the girl's sweet tooth as she was keen on it being ready to take root. Deciding she had gathered enough from Stasia for the night, she quickly swiped a bracelet sprawled across her vanity that was engraved with the phrase "daddy's girl." She placed the journal in its color-coded place and slowly exited the room, taking in the essence of all its belongings. The woman clacked her heels together swiftly, then again, and again.

"Didn't you know, Stasi? There's no place like home."

She walked down the narrow hall and back into the living room space. She looked at the beautifully plucked roses draped across the sofa where they had lain the entirety of her short, but successful visit. That gift was for Stasia. It was the

least she could do for the young lady who would make her young and desirable again.

With the clack of her new heels and the clink of the bracelet barely hanging off her wrist, Ann descended to the lobby in the elevator, remembering to lock the apartment door behind her and leaving it as it was before. The elevator door opened in front of her as she glided across the floor to the exit.

Ann caught the eye of the previous employee where she had been upon her arrival.

"Oh you're done?" she said. "I'm sure your daughter will be so happy when she arrives! I hope your visit served you well Ms. …."

Ann paused, looking at the gliding doors for a moment. She turned around and replied with a menacing grin. "Pritchard,"

"Ms. Pritchard," the employee said and smiled back.

The name already fit her like a glove.

14

THE GRIN

———

The days may wane, and the time may fade, but
the hurt and pain makes a promise to stay.

The morning was fresh, and all was still in the Moore household. It was a Sunday around 8 a.m. when Elliot was awoken by the scent of sweet maple sausages. It was strange to smell such a scent since the previous summer's accident. Dad wasn't keen on the art of rotting teeth, so he had never objected to the opposition of cooking processed diabetes in synthetic casing, as he would call it.

It had to be Mom.

Elliot sat up disoriented in his bed. It had become a common occurrence for the past few weeks, regularly coming and going. Maybe it was sinuses like Dad suggested. But honestly, who would believe him between Dad being convinced that he was actively trying to avoid the forced social interaction he and Drew were enforcing, or Mom's strange comeback. After pondering in his own thought, he stood up disheveled and walked toward his door where he opened it to a slightly taller figure staring right back at him with glossed over eyes.

"Drew, what are you doing up so early?" questioned Elliot.

Drew stood at the door for a few seconds boring holes into her brother's eyes with a glossed over look. She stood worryingly still. As Elliot cautiously stepped forward, instant panic filled his small body. Drew's cold lifeless figure tipped forward and tumbled to the floor, barely missing him as he jilted to the side.

The adrenaline in his body led him to freeze at the sight of an all too familiar inhumanly grin that stretched from ear to ear. He could see a missing molar as he tried to understand what monstrous figure stared so intently back at him. The sunken eyes of the lanky and slow-moving body proceeding toward him emulated his mother but lacked all that made a mother up to be. A kitchen knife brandished the boney decrepit hands that once belonged to the mother he found solace in. It came closer and closer to him with dead eyes. He could now feel the drench of his sister's blood that spurted from her back and onto his cold feet.

Elliot attempted to move as the sinister being made its way closer toward him. His cottonmouth restricted his function to call for help, although he knew there was none. His chest heaved at an erratic rhythm. His eyes followed. It was as if he were a prisoner in his own body forced to witness the terrors around him while in a conscious state.

"Elliot!" Drew shouted. He sat in place dripping in sweat for a few minutes before he jolted at his sister's touch.

"Bub, get it together. You're spilling water all over the floor!" Drew said as she yanked a now empty glass out of his limp hand, "I think Mom's making breakfast ... what's wrong with you?" she continued to questioned with a bewildered look on her face.

"Bad dream," he replied as he looked wearily around his room. *Hallucinations? It can't be? It was too real.* Elliot

thought to himself as he gained function in his limbs once more. Looking behind him at his desk-side clock, he could see that it was now 8:13 a.m.

"Are you trying your hand at being a human statue now? You're only in fifth grade. You have time to choose a better profession, otherwise you're asking to get bullied. Why did you have this in your hand anyway? You're usually in bed asleep?"

"I don't know. I think I might've gotten thirsty during the night or something. You know that throat thing's still bothering me."

"Speaking of that, I think you brought something home. I keep getting stomachaches and some weird throat cough. You really need to stop pot-lucking with Nikki at lunch."

Elliot continued to look around his room in astonishment of what he had just witnessed or hallucinated. Drew looked at him as if he were a goose laying a golden egg. "Are you coming?"

"It's a bit early, Drew."

"When was the last time you smelled maple sausages?"

He pondered and thought his older sister was considerate enough to not hog them all for herself. They both walked toward the door, but he couldn't help himself from thinking about his strange reoccurring delusions he had. *Why did they keep getting more real?* The only things more consistent than the delusions were the nauseating headaches that accompanied it. He took a pause at the door before leaping out into the hall to see if there were any more ghouls waiting for the taking.

"Seriously, what *are* you doing?" asked Drew. Elliot could see the slightly annoyed expression written on her face.

"Nothing," Elliot said, "I ... nothing."

"Just make sure you don't do that at school. Dad said people will think you're soft."

"Whatever that means," retorted Elliot.

Drew shuffled down the stairs in an oversized graphic t-shirt as her younger brother followed in sci-fi long johns. Drew fashioned fuzzy slippers; one of Elliot's feet was met with the chill of the morning ground as he had forgotten to put on his other sock. Making their way down through the house toward the kitchen, the two siblings braced themselves for what smelled like sausages and pancakes.

When they entered the kitchen, the two adolescents paused only to see the backside of their mom in a nice vibrant green sundress and bleach white apron. Her hair was slicked into a modest bun and her pearl necklace made what they could see of her even more put together. One would think dressing up for breakfast so modestly, yet sleek, would be absolutely too theatrical, but that was how Dad liked it before the accident and his dad before that and his dad before that. The men wanted a show, and it was expected of the women. Their mom must have been reverting to her old self.

Maybe Drew was right? Maybe Mom was getting better.

Both Elliot and Drew began to drag their seats from under the dining room table when they were met with a shock.

"Good morning, kids."

"Good morning, ... Stasia?" both kids said in unison. Confusion crowded Elliot's mind. *Nobody said that she would be over this morning,* he thought to himself. Drew must have been thinking the same thing as her attention shifted from Stasia to her brother with an inquisitive look.

"What are you doing here, it's Sunday?" Drew questioned as she gazed back at Stasia.

"And why are you cooking for us?" added Elliot, also giving her a deadpan stare. "Only Mom cooks that for us."

"Well, your mother invited me here of course."

"And why are you dressed like that?" Drew asked. "Your hair looks different. It looks like Mom's or at least how she used to wear it."

"Don't you have a sharp eye, Drew?" a voice spoke behind a wall that led to the kitchen. Mrs. Moore walked out from behind the wall revealing her accented gown with green floral patterns. It was much more youthful than anything she had ever seen her mother wear. "Writing those little Nancy Drew like stories must really be serving you well, my dear."

Drew slightly smiled at her mom's assertion.

"You should join us ladies next time. Learn how to cook your way into the heart of others. That's always been my specialty," her mom stated.

"Hopefully, it can now be mine," joked Stasia.

Both children were still confused as to why Stasia was there and why their mother chose to teach her such tasks early in the morning. Sure, she said one thing, but her actions were so odd. The two watched Stasia and their mom's movements in the kitchen, gazing at what was happening. The light blue plates sat neatly on the counter where one large pancake decorated with marshmallows in the form of a smiley face was placed. Stasia popped two maple-smoked sausages on the side of each of the four plates as she finished cooking.

"We shouldn't eat without your father," said Mom. "He should be coming down any time now." Within the next ten seconds, an equally dazed and sleepy Dad waddled down the steps and into the kitchen rubbing his eyes.

"Is that maple sausage I smell?"

Her calculation was almost as scary as it was impressive. The family looked at Dad without saying anything. Slight confusion was written over the children's faces as they continued to question the two women's actions. Stasia continued to look on with welcome in her eyes and amusement in mom's.

"Uh, Stasia!"

"Hello, Dr. Moore?"

"Are you? Are you supposed to be here today? It is Sunday, you know?" he rhetorically questioned, rubbing his head and closing his navy robe after catching a glimpse, Mom stood next to Stasia.

"Yes, sir, I know that."

"Mother invited her," said Drew.

"Oh, uh, are we paying her extra, honey?" asked dad as he inched closer to his wife and lowered his voice a bit to where he imagined Stasia could not hear.

"Like Drew said, I invited her ... and she accepted. She's being paid in companionship. Isn't that much better?" Mom grinned at their father and back at Stasia.

"Your wife has been giving me cooking lessons, and I can say it's honestly helping the both of us out."

"Right," Dad replied and then nodded.

"Sit! I'll bring you your plates," insisted Stasia.

Holding all four of the plates in her arms, she neatly placed them on the matching placemats in front of them at the long dining room table.

"Reminds me of your diner days, honey," Dad stated to Mom as she leaned on the wall observing it all.

"I guess that would, wouldn't it," Mom said back.

Elliot couldn't help but to continuously catch swift glances of his mother. She had a glow about her that was unusual to this household, especially in the past few months.

"Eat up!" Stasia sweetly announced, wiping her hands on her apron.

Dad's knife quickly dived into his pancake before stopping.

"Aren't you going to sit too, Ann?"

"Yeah mom … you should sit," agreed Drew. Elliot said nothing as he intently stared at his mother, her staring back with equal intent.

"I believe Stasia should sit. After all, she did cook this nice breakfast for you all, didn't she?"

"Oh, are you sure?" questioned Stasia.

"Well, the table is set for four," she stated as she motioned toward the open seat at the head of the table.

"Sit."

Stasia obliged the orders of Mom and sat. Dad resumed plunging his knife into the smiling pancakes without missing a beat, scarfing down a bite of pancake with a chunk of sausage like a vacuum. Drew followed suit, and then Elliot as he carefully examined the meat.

"You know, this is really good. You did a great j-Ow!" yelped dad. He shifted his mouth around slowly as he had a mouthful of pancake coating his tongue.

"Something wrong?" questioned Mom from afar, her vibrant green dress popping out of the monotonous backdrop of the wall she was leaning against. She truly looked as if she were turning a new leaf, but at whose cost?

He held out a napkin and carefully spit out a tooth.

"Is that a tooth, Dad?" asked Drew, eyes widening in disgust. "You must be getting old!"

"It's not mine," he confessed as he carefully picked up and examined the foreign object disguised as a marshmallow in his pancake.

"It's a molar," stated Dad as he carefully examined the tooth he had just spat out of his mouth. "Huh, you must be a practical joker, Stasia ... a morbid one, but hey, Moore smiles, right!" he joked a bit uneasy.

Drew groaned at her Dad's joke while Elliot continued to stare at his mom, changing his gaze to a glare.

Mom scoffed and grinned in amusement once more before disappearing behind the wall.

"Where is Mom going?" asked Elliot.

"Nowhere, son. She's probably just going back up to our room. Just because you don't see her doesn't mean she's not here. Eat the rest of your food."

15

THE VILE

––––

After breakfast, Stasia bid farewell to the Moore household
and ensured her return the next morning on Monday. Step-
ping out of the front door and into the walkway that lead to
her parked vintage bug, she swayed in her white sundress
and modest sandals. Mr. Moore stood in the door frame
with Elliot and Drew on either side of him, watching as she
left the house. As she looked back at the family, she tilted her
head up to the second floor, where she could see Ann's figure
envelop the window as she looked down at her. Her face was
blank, providing little emotion. Stasia decided to wave at the
woman who was constantly surrounded by mystery. Ann
continued to look down at her as she slowly held her hand
up, bidding her a farewell only to quickly disappear from the
window frame and into the house.

Stasia opened her car door and settled in the driver's
seat slamming the door shut behind her, putting the key in
the ignition. Her keychain jiggled as two charms clacked
together. The rose charm had been gifted to her on the eve of
her thirteenth birthday. Her father said it should remind her
of "his only daughter close to his heart." It comforted her to
know that as long as she kept her rose around, she would be

in the solace of her father. Because of the increasing influence on her, Ann never escaped Stasia's mind lately.

She found it awfully sweet Ann was willing to teach her how to cook and share her spaces with her after a delicate time in her own life. Although she was technically paid to be at the Moore residence, she found it necessary to return the favors of Ann Moore. *Possibly antique china would impress her? No. That's a bit much. A book to suggest to her club? Actually, I don't see her returning any time soon. Maybe her own rose charm?*

Stasia put her foot on the gas pedal and looped out of the cul-de-sac of Walnut Drive. As she went on her way, she pondered about the rose charm as a choice for a gift. It held sentiment and appreciation and she knew that Ann had continuously caught glimpses of her own. *Our friendship will be brought closer,* she thought, oblivious to a flower's thorn.

She continued up the road to her apartment. Her roommates had returned a few days before from their spur of the moment casino run. Entering the apartment building gates and parking her car, Stasia hopped out and made her way into the apartment lobby. It was her first day back since staying at her parents that Friday evening and entire Saturday. Before taking the elevator up, Stasia remembered to check her P.O. box, which she hadn't got the chance to in her absence.

"Hi, can you check to see if I have any mail in the box for apartment 2503?" she asked after walking up to the apartment concierge.

"Of course. Your name?"

"Stasia Pritchard." The concierge walked off to the mail room to fulfill the task. She heard footsteps as the employee quickly returned from the back with a small yellow envelop bearing no return address.

"This is all," the concierge stated, looking up at Stasia with familiarity in her eye. "Hey, I recognize you! I was unsure if you made it back yesterday to see your surprise! I worked Friday evening and not yesterday, so I didn't get a chance to see how things went. So nice of your mother."

"Pardon?" Stasia questioned in a puzzled manner, not sure in the slightest of what the concierge was referring to. "Sorry, I'm not sure what you are talking about. I was away from my apartment yesterday."

"I am so sorry, ma'am, I didn't mean to ruin the surprise your mother had left you. She came around the other day saying it was your birthday and … I'm giving too much away. You'll see when you get up there." Said the concierge, fashioning a cheesy yet apologetic smile.

Stasia stood perplexed at the employee's proclamation. *Mother?* She had been with her mom that entire weekend, and when she wasn't, she was at the Moores'. She shook off the odd conversation and left the concierge desk with a swift "thank you," taking her obscure small package in hand. Pressing the elevator button, she couldn't help but wonder who the hell could have entered her apartment while she was gone. Was any truth to what the concierge was saying?

Birthday? That wasn't for months. Maybe it was Micah or Penny pulling one of their drunken pranks on the poor inhabitants of this apartment building. There was no telling if those girls were just hung over or still tipsy upon their casino trip return. The elevator doors glided open. Much to her surprise, Penny was exiting its doors.

"Stasia!" Penny yelped in pain as her hand touched her head, most likely from a headache.

"Penny! Where are you headed? You look—"

"Grotesque. I know. I could've sworn bottomless bars at the casino didn't sound as intimidating on weeknights, but you can call me Bozo."

Stasia nodded in astonishment at her roommate's habits. "Right, where's Micah?"

"Knocked out upstairs. You think I look bad? She spent the entire Saturday doing the same thing. I'm going to get us both more medicine and food. Want something?"

"Uh no, I already ate at the Moores'."

"I shouldn't have even asked. You look like you're dressed to join the Brandy Bunch."

"It's Brady Bunch and very funny."

Stasia let the elevator doors close as Penny began to wander off into the lobby, but Stasia quickly stopped her before she got too far. "Penny, did anybody happen to come into our apartment yesterday? I wasn't there and the concierge was saying something odd about a surprise birthday thing."

"No … I mean Micah was still pretty gone when we got back, so who knows what she could've said to the people here."

"Right, right," Stasia said nodding her head in agreement. "But was there anything in the apartment? Like a surprise or something?"

"There might be in the bathroom toilet thanks to Micah," Penny asserted with a toothy grin. "Honestly, if I don't go get these things now, you can count on there being double the surprise."

"Sorry," Stasia quickly apologized, letting go of her roommate's forearm she had been holding to stop her from leaving. "I'll probably see you later."

"Touche," her roommate yelled across the lobby as she walked away out of the building.

"It's touché!" Stasia attempted but failed to yell back. She once again mashed the elevator up button to get to her apartment. Entering the elevator, she began her ascend up to 2503. As she pulled the keys out of her bag and jingled them into the apartment door, she entered her place to the stench of her two roommates. Peering around, she saw nothing different from how she left it upon leaving a few days prior other than the jackets of her roommates sprawled across the sofa. Stasia moved on and decided to retreat to her empty room where everything looked untouched as she entered. She flung her small package onto her bed where it plopped and stayed. Finally, she could release her feet from the white heels she decided to wear.

She found herself attempting to impress the Moores the more she went around, especially Ann. She didn't know how she managed to do it all before her arrival, but the least Stasia could do was try to emulate that the best she could while imitating her presence. *Right?* She slipped her feet out of the shoes and onto the cold floor that shocked her skin. Opening the closet door, she walked in and neatly placed the shoes dangling from her finger tips in an empty space on the floor.

Standing up and exhaling slightly, her eye was caught by a pair of white homey sandals foreign to her closet. She wasn't familiar with this pair of shoes as they seemed a bit out of her age range. *Maybe Penny or Micah had something to do with it? But where was the joke?* She bent down and picked up the pair of sandals to examine them. The size fit hers and they seemed to be a bit worn, but when did she buy them?

"They really must think I'm a real mom," Stasia scoffed to herself, thinking about her roommates' prior comments insulting her job for the Moores. *How practical,* she thought.

The young woman set the shoes back down, unaware that days prior Ann had left them as a gift. Stasia stood upright and made her way out of her closet, shutting the door behind her. As she walked around her room, sunshine pooled through her window and hit her face with warmth. She made her way to the bed and plopped down beside her package. She looked to her side and grabbed the package, attempting to open it with her bare hands while lying down. Unsuccessful, she decided to grab the mail opener on the side of her desk and slice the tiny yellow package open.

"Ouch!" Her index finger glistened with red blood, trickling down her finger slowly. Unable to find a Band-Aid quickly, she let her tongue heal the wound by sucking the blood. Using her free hand, she sat in a cross-legged position in her spacious queen bed and shook the mysterious object in the package out. A small glass vial with a clear liquid fell onto her lap. A cork was the only thing preventing the liquid from its escape.

*Who would send such a thing? What **was** this thing?*

Not wanting to wake her slumbering hungover roommate, she decided to leave the tiny vial on her vanity next to her plentiful collection of perfume bottles. *"It would be a nice time for a nap,"* she thought. It would be the last time she probably got much of it.

16

THE PATRIARCH

—

Senior or Pritchard, Sr., as many called him, was a man of virtue and value. To his daughter Stasia, he was all that she needed in a father despite his average flaws and vices. When she needed him most, she could count on him to be there. First birthdays, first times, first losses—he was there.

For Ann Moore, Pritchard Senior was cloaked in invidious offense. To this offspring, he was never there when she needed him. When she looked to him most, his image dissipated. First birthdays—gone. First times—gone. First losses—he was just that. Many years prior to meeting her husband Mark, the reality that Pritchard Senior failed to even acknowledge her existence and wiped her from his memory after those some odd years ago planted a seed of agitation in her heart. What made that seed grow into a bush full of thorns was her discovery that the identity she was once on the cusp of had been auctioned off to another little girl named Stasia Ann Pritchard.

Senior was a devoted man to his first wife and abided by the laws of marriage for fifteen years. Upon the fifteenth year of marriage, there was a shift in his heart, and in turn, the Pritchard household was turned upside down. "Home is

where the heart is," he used to say. With that statement, his heart strayed. Extended days at work began to turn into nights on the job and later, nights not at home at all. Ann felt the bitterness entering her mother's heart, partially because she blamed herself for Pritchard Senior's departure. As a small girl, she watched her mother sit on an empty couch, staring into a house that was no longer a home. She remembered the pitter patter of her feet on the wooden floors as she attempted to comfort her mother with a hug, a kiss, or her presence. Her mother faded away with her identity she built in the proximity to her husband. With him gone, she too was no more.

How should one be quit in the same manner as a nicotine habit? Ann grappled with it for years as she grew into a young woman. She felt disposable to the men surrounding her. If she wasn't placed in a diner as eye candy who served the needs of men, then she must have conformed to the life of a trophy wife as her mom had been, but neither seemed like a suitable option. That did not matter, these options were prescribed and nonrefundable. She learned soon enough that there was no agency in her life as she had dreamed about as a child. Life was a raffle, and by any means, she would hustle the game.

And then she met Mark Moore. Mark Moore had an air about him that exuded agency, obnoxiously so, but from the first time she met him, she knew he had promise and security. The promise and security she lacked in Senior, she found in Mark. Sure, she would morph into the wife her mother once was, but she assumed she knew how to cheat the outcome her mother was once met with.

She didn't love him enough.
She didn't clean enough.
She wasn't supportive enough.
Maybe he hadn't meant to leave.

These were all thoughts that crowded her mind regarding her parents as she became fonder of Mark Moore. She felt for her mother but couldn't understand why a seemingly perfect marriage was wrecked in an instant.

Stasia had been born the spring that Ann turned nine, just a month or so after the fateful day when Senior left. Ann and her mother were cut off in all aspects of the word. It was as if Senior had just been a figure of their imaginations. Bank accounts lay frozen, the home stood cold, and divorce remained impending. He had become an untethered figure, leaving without the simple act of notifying his soon to be ex-wife and daughter about his whereabouts.

The pain of Ann's mother was immeasurable as she became a catatonic shell for weeks, months, and years on end. Ann vowed to never become familiar with such pain again, which she *hadn't* until the later years of her marriage to Mark. The glint in his eye when he looked at her had faded along with his appreciation for all she had done as a mother and wife. The resentment she had for her father had leapt on her back once more as the hysteria of losing her own identity doubled the strain on her mind. If she was not a Pritchard or a Moore, *who was she?*

What was she here for?

A frost consumes trauma at its peak.

17

THE OVEN

———

It was the previous summer. It was a bright day where sun rays washed through the Moore household like glistening golden showers. The house was unusually warm as the feet of its occupants never touched the cold temperatures of the wooden floors. It was just as hot outside with a small breeze in the air. The little breath of relieving air swept through the scalps of children playing dodgeball and tag in the streets and in their front yards. Sprinklers hit the front windows with pitter patters and flower beds dripped in sweat. The Moore children were out and about during the summer day.

Elliot had gone to Nikki's in search of popsicles and cards that they could trade with other neighborhood kids willing to converse with them. Drew had convinced her mother that it was worth her while to visit the mall with other kids from her grade. Both Ann and Mark obliged, only for Mark to trail off behind his children on an outing himself. He was off to the golf course with Mr. Thibault once again. His days and evenings were becoming consumed by golf, the dentistry, and the occasional fishing trip, all of which Ann understood as "essential gentlemen's time." She had her book club and he had his getaways.

With an empty nest and without an intention in sight, Ann began to give thought to her place in her marriage, her family, and this world. She felt tension in her back, neck, and legs as her head ached in pain. Nothing had been wrong with her upon her last visit to the doctor. The man explained, "You're just a mother overworking yourself, but what's being a mother if you don't?"

She was *just* that. A mother. A wife. A daughter. Not Ann. The tension at the base of her skull had habitually began to throb for weeks on end. Her husband's passive attitude that had been mounting for months, or maybe years, did not help much as she tried to entertain and care for both of them in the largely one-sided relationship. Ann had taken up a hobby for moments like these in which she was left alone without a task where she could define herself.

It wasn't as if cooking and cleaning were hobbies since they were essential to the functioning of her family, but it was what those around her believed she was good at, so why not make it a hobby. Ann began to seek companionship on online forums where she found commonalities with others. She tried bakers' clubs, motherhood sites, and even online book clubs, but found them just as trite and arbitrary.

That particular summer's day, sitting at her husband's desk, a waft of curiosity washed over her. Why was it that the same resentment that mounted in her chest as a young girl returned when she looked in the eyes of her husband of eleven years? A physical and mental void had begun to absorb those four walls she inhabited, and there was nowhere to escape this time.

Ann began to search for her father, much to the opposition of her past vows as a young girl. She felt she deserved a straight answer as to why she had become an afterthought.

She was becoming the living corpse she witnessed her own mother turn into before her eyes as a child, and she felt just as demented as her. As she typed in the name of her father, Pritchard Senior, thousands of names glowed in her eyes. None of them had a definite answer to the whereabouts of her estranged father.

Quincy Pritchard was all she knew of her father, who was a businessman. That was the only tangible evidence of his existence she held onto; the rest of his identity had become tarnished by what he failed to become rather than who he had once been. It was riveting that no matter how many good memories she had made with that man, it was impossible to remember them any longer.

Quincy Pritchard. Carter County. Businessman. Last known address 40 Creek St.

Searching...

Searching...

Searching...

Nothing. Nothing came of her short search for her father, and a part of her liked it that way. He did not deserve the benefit of her time; unfortunately, she was beginning to learn this the hard way, once more with her own husband. Her eyes glazed over at the monitor as they often did during that lonely, warm summer.

Local poet wins academic prize for poetry collection -Carter Gazette

Stasia Pritchard has won one of the state's most prestigious poetry awards for her zine of collected poems. Her self-published zine titled The Proverbs of a Lady *note the intimate complexities of life as a woman. To her right is her mother, Lana Pritchard and to her left is her father, Quincy Pritchard, Sr.*

Ann's head began to throb at a rapid pace as her eyes began to see an arrangement of vivid colors. The image of her estranged father she had blocked from her memory for several years had a face to it once more. It was unfair that, in an instant, he could write himself back into her life despite removing himself so forcefully without any regard for her. *Was this the woman who had ripped her father away? Was this child a bastard that drove her mother comatose?* She sat back in the chair, mouth agape, staring at the ceiling for several moments. Head still swirling, she brought herself to type in the name Stasia Pritchard once more.

@stasia.pritchard. Caper High School Alumni, Principal's Cabinet, Dean's List First Honors four years in a row, Miss Gamma Gamma Kappa Debutante Queen, Princeton Alumni, Red Cross Advocate, UNICEF Volunteer, Honors Student, and freelance poet residing in Carter County also known as Stasia *Ann* Pritchard.

The influx of information in such little time sent an already unhinged Ann into a tailspin. In a moment's time, her world seemed senseless. The lack of identity she grappled with was now decrepit and obsolete. Quickly turning the computer off, the woman rose to her feet, which she no longer could feel, and stumbled into her bathroom. She quickly began running the tap in the sink, splashing it onto her face and attempting to find some sort of sensation.

She could feel nothing but a void that her body couldn't find the way out of. She gasped for air, but her throat was dry and scratchy with the strain of agony. It was as if she no longer existed. She stared in the mirror as water dripped from her face. She was only able to see the reflection of a grotesque body that bore dark eyes and tired rubber skin. She had been

losing whatever recognition she had created for herself, and that last piece had just disappeared.

Her elongated, slender fingers opened a drawer where her husband's shaving razors lay. Pulling one out, she stretched the top of her blouse and began to carve the outline of a small kitten just above her collarbone. She wanted to feel something. She was deprived of the opportunity to even feel anything. Abandoning the blade in the still running sink now pooled with blood and cold water, she began her way down the steps, dripping red all the way down. There was a distance in her eyes as the sun shone on her body. The sound of children's laughter and bike wheels rolling was juxtaposed with the lifeless vessel that was once Ann.

It was hot. So hot. But the bottom of her feet welcomed a familiar coldness she knew all too well. Ann had been baking a pie just before her discovery. She had forgotten about the sweet treat that she intended to surprise her family with as it burned in the oven. *They were going to love it.* She slowly dragged her feet into the kitchen where she moved her seemingly floating body over to the oven. Her slender hand grabbed the handle of the oven and opened it as small wafts of smoke pooled out. With her bare hands, she removed the pie and let the dessert slip from her hands and onto the ground as crumbs and remnants made its way in every direction. Placing her head directly on the oven bars, she couldn't even muster up a guttural sound to express the physical pain of her scorching face. Her soul nullified. She had felt enough.

As minutes passed, children outside continued to play in the bright sun. The game of tag had entered its ninth round, and the biking kids had the confidence of a professional. One tiny boy halted his yellow bike as he saw a tiny hummingbird pass in front of him. With his yellow kneepads and helmet

to match, he waddled across the front lawn belonging to the Moores. He attempted to catch the equally tiny, but small hummingbird that made its way to the rose bushes near the front window of the house. Perplexed by the beauty of the hummingbird with a wine stained neck, he giggled to himself as he attempted to catch it, only for it to escape as he clasped his little hands together. Defeated, he looked up and peered into the window where he managed to see small puffs of smoke coming from inside the house.

"Mom!" he yelled to a woman in khaki shorts and a collared summer blouse. She had been just behind him on the sidewalk, speaking with another woman of the neighborhood.

"Sweetie, get off their lawn! You know you shouldn't be over there!" she nagged at the small boy.

"But Mom, I see some feet …," the boy managed to mutter with a confused yet concerned look on his face as he turned back to his mother pointing in the direction of the window. "I see some feet," he said again as his mother ran closer to him.

She managed to peek into the window to make some sense of her young son's claims, only to hear the beeping of a fire alarm and the seemingly lifeless body of Ann Moore on the kitchen floor.

18

THE TRUTH

Be with me in spirit be with me in soul our
hearts will mend together forever is just a toll.

The evening was lax as the day wound down. Stasia had just picked the children up from school as it had come to an end that Tuesday morning.

"How's it going you two?" Stasia questioned from the front seat, catching glimpses of the slumped children riding in the back of the family car. "You look a little …"

"Sick. Yeah, I realize," snapped Elliot, glaring into the rear view mirror.

Stasia was a bit taken aback by his disgruntled face but brushed it off. Ann had said he was going through pre-pubescent mood swings as he was on the cusp of puberty. Actually, Ann had said a lot of strange things had been happening with her son. Disgruntled attitudes, lies, anger, and even hallucinations, strangely enough. Nodding her head and looking forward at the road once more, she pressed ahead.

"Are you still skipping your classes to go to the nurse?" whispered Drew to Elliot.

"They're the only ones I can trust," he said, still boring holes into the back of Stasia's head from the front seat. "It's not like Mom and Dad are taking care of me. I've been feeling weird for weeks and it doesn't matter."

"Okay. One. What does that have to do with Stasia? You keep scowling at her like you want to scare her away. And two. They think you're faking it for attention. So, you can escape getting bullied or something," replied Drew.

"That's not true! Dad is just useless and Mom's out to get us!" he replied loudly.

"Woah, woah. Calm it down back there. I know parents can be a drag sometimes but I'm sure your mom isn't out to get either of you," Stasia chimed in after eavesdropping.

"I **know** what's true, and you are the last person I'd look to if I needed the truth!" barked Elliot.

The car glided to a halt as Stasia placed her hand on the back of the passenger's seat and turned around to face the two children. They *had* looked pretty under the weather for the past couple of days.

"Look, I understand I am not your mother, but I am just attempting to help. Is that so bad?"

"Well, in Elliot's defense, you don't act like it. Look at how you dress now. You're beginning to look like her," Drew pointed out, prompting Stasia to look down at her blue floral button up blouse and long khaki pants.

"But I paired my outfit with a chunky headband," she tried to joke, pointing to the oversized white accessory atop her crown.

"What do you and her even talk about for all the time you're at home? What's the point of working if you aren't doing any work?" interrogated Elliot once more.

"Just lady things. Ya know we share recipes, books, and things"

"Exactly what things?" bombarded Elliot.

"What is with you kids today!" asserted Stasia clearly frustrated.

"Like he said ... we're sick," said Drew.

As they made it to 40 Walnut Drive, the pair of kids didn't wait until the engine had cut to hop out of the car and walk into the house. Stasia began to search the glove compartment of the truck where she had stashed her present for Ann. In the small black box that hid between car notes and the registration laid a rose charm identical to Stasia's own. She had thought it would be a nice gesture to repay Ann for her companionship that she was beginning to view as sisterhood, one that she hadn't grown up with to the liking of her Quincy Pritchard, Sr.

Unknown to Stasia, she and Ann were more than just soul sisters, but blood. Stasia stopped the engine and exited the car, shutting the door behind her with her gift in hand. It was only a wonder why those two kids were so increasingly hell bent that Ann didn't spend time with her. It seemed a bit excessive and rude.

As she walked through the door, she could see the opposite door leading to the backyard had been flung open. The sky was a burnt orange color and powdered clouds scattered the sky. Stasia strode down the hall as the children immediately retreated to their rooms. *It would just be best to let them be rather than agitate them further,* she thought to herself. As the fresh air hit her face once more, she couldn't help but close her eyes and inhale stretching her limbs toward the sky.

"The sun hasn't even officially begun setting yet, but it looks beautiful doesn't it," Ann said appearing from behind the house. It was as if she knew Stasia would make

her way to her like a magnet. Ann stood as if she were expecting her.

Slightly startled and embarrassed, Stasia nodded her head.

"Yes, it is beautiful. I guess you are doing the same as I. Enjoying the freedom of the outside," Stasia voiced.

"Enjoying anything that isn't as smothering as that cold house some call a home," Ann stated walking closer and sitting down in a white lawn chair by its matching table.

"I can turn the AC off if it's too cold," Stasia replied, ignorant of Ann's true connotation.

"No need, sit down," demanded Ann. Stasia quickly followed suit, taking the empty chair on the opposite side of Ann.

"While we are here sitting, I would like to say something," Stasia suddenly revealed.

Ann's eyes narrowed as her defenses went up. *Does she know?*

"What would you like to say? Don't tell me you're leaving us," the woman obnoxiously laughed, posing as an unbothered person that was actually deeply disturbed.

"Of course not! I just wanted to say thank you," the young woman proclaimed. "Thank you for the sisterhood you've created between the two of us. Although I know this is my job, I feel like I'm really becoming part of the family with my role here."

"I'm glad you see it that way," Ann stated nodding along with her assertion.

"Yes, I'm glad too, but that isn't all. I just wanted to repay you for going above and beyond getting to know me. I saw firsthand how shallow some people can be, especially at the book club and just in life in general. So I got you a gift!"

Ann's brow creased once again at Stasia's statement.

"I saw how you often looked at the rose pendant on my key chain and thought it would be nice to get you your own.

My father, Pritchard Senior, gave me mine on my thirteenth birthday as sort of an introduction as a new girl. I thought since you're getting better and we're becoming a lot closer like sisters, it would fit if we had matching ones."

"Stasia …," Ann trailed.

"If it's too corny let me know … oh, and if it isn't your style, feel free to tell me that as well … I just thought it would be …"

"It is wonderful," Ann said as she popped open the box that Stasia had laid on the table.

"I'm so glad you like it!" the young lady proclaimed ecstatically.

"I hope you liked my gift as much as I did yours," responded. There was a modest curl of her lips at her statement.

"Gift? You sent me a gift."

"I figured that you would have gotten it by now, but you never mentioned it."

"I'm sorry I'm not sure what you're referring to."

"The vial, silly."

"The vial … the vial … the vial …," Stasia pondered as she clacked her fingernails against the table surface. "Ah! The tiny one? In the yellow envelop?"

"Of course."

"Oh, well it didn't have a return address, so I had no clue who sent it. I thought my roommates were pulling a prank on me to be honest."

"Keep it close to you."

"I'm honestly not sure what it is, to be truthful."

"Like the charm, it will allow you and me to become new women."

"Ah, I see. Perfumes can definitely do that," Stasia stated assuming that was what Ann meant.

"Stasia."

"Yes, Ann?"

"The liquid in that vile is thicker than blood."

"Pardon?" Stasia questioned in a confused manner once more. The two sat and stared at each other in silence for a few seconds as the conversation had gone off beat. The blast of Ann's laughter interrupted the silence. She waved her hand in the air delicately as she held her chest in an attempt to calm her chronic laughter.

"Oh, silly me!" Stasia joined in Ann's laughter giggling about.

"Right, silly you."

19

THE REVEAL

———

An illness had swept over the Moore manor like buzzards swarming a carcass. The house had grown dull and lifeless each time the family of three and matriarch of one entered its walls. Little Elliot had come down with a severe illness that was met with his father's dismissal. Dad had convinced himself that his children were out to ruin his health and business by bringing home the germs of adolescents.

"But Dad I *am* sick," Elliot would insist.

"What is it then, bub?" his dad would haphazardly reply.

"Nausea"

Stop eating expired food. See your mom.

"Sore throat"

Take a lozenge. See your mom.

"Muscle cramps"

Growing pains. Toughen up, my man.

"Tingling toes"

Boy are you soft. See your mom.

If he wasn't getting paid, it wasn't his job. *Then whose was it?* There was no "mom" when it came to Ann Moore. She was gone and she had changed. The soul in her eyes had run away, and it was as clear as day to Elliot. He could

no longer find solace in either parent for the nurturing he required.

Possibly Stasia could have helped, but she too was no good. What woman would spend that much time with his overtly strange mom? It wasn't a regular type of strange, which his classmates slagged off their boring, yet embarrassing parents, but rather an unnerving presence she had begun to retain. *What woman would become friends with someone like that unless they too were just as sinister?*

It was as if the young boy's panic and hysteria had fermented itself in the certainty that there was no adult he could look to. There was no safe space or sanctuary, only an asylum for those with unsound minds. The infrastructure where a home once stood had mutated into the frigid house of his mother's memories.

"See your mom," his dad said to the distaste of his son. Had he not looked up to notice the family he had taken credit for building was crumbling, or was that also too much to ask of a self-absorbed man? His ignorance to his son's problems had already driven a wedge between the two but had put his offspring's safety on the line.

He knew that the person he had come to call Mom was void of any sort of compassion she once had. Between the constant hallucinations and the bodily agitations he had been experiencing, Elliot began rejecting food as Ann continued to reject her so-called family. The boy had grown even thinner and garnered a tint to his skin that alarmed his schoolteachers, schoolmates, sister, and, occasionally, his clueless father.

For someone so smart, Dad could be so aloof. Elliot would have much rather have hung tight with the nurse until the legal age of emancipation rather than face his mother, who he noticed was beginning to retain a glow she had, oddly

enough, never had before. Upon being sent home sick from school, the boy would have rather jumped into traffic than gone home to his mother and her henchman, Stasia. *They had done this.* But who would believe him? *They had done this.* She was the one who conceived him.

19.1 THE REVEAL

They had done this. His children had come home sick with the "flu" as children do. Mark's mounting agitation with the confines of his home grew at odds with his kids, especially Elliot. The way the kid looked at him in resentment, as if he had something to say but could not say it at all, made his state of being home sick all the worse. *If only he could handle his issues like a man, then maybe he could come to me, maybe he would have some other friends, maybe he wouldn't have to be coddled like an infant still attached to his mother's bosom.*

They had taken his beautiful wife and made her into a cow whose utters were slaves to them. She was no longer subservient to him, but to them. Whatever happened to "behind every good man is a woman?" She had been the embodiment of that for years until her attention splintered with the birth of children. Oh yes, they were white-picket blessings, but they came at a trust fund price. Days and nights in which Ann would dote on Mark were replaced with days and nights of "I'll put him back to bed" and "She has to have her favorite bear."

The glint in his eye faded with the demands of parenthood and the habitual routines of suburban life. It was true that he had lost interest in the focal pillar of his life, but all the years standing on her support were obsolete, just because they could be.

Mark's heart began to murmur in many ways; for new love, new interests, and for new pain. One of which Ann supplied.

19.2 THE REVEAL

Her body thrashed and cried through the night at the assumption of the unreal. Between her brother's hallucinations and her deep discomfort that swarmed her mind, Drew was almost positive that there had been a shift in her soul. She had developed sore throats for days on end and fashioned the same tint in her skin as her brother. Quarantined in the household by her clueless father, who swore the illness was the flu, the walls began to close in as she, too, felt a strangeness that her brother had been mentioning.

The number of lattice pies she had consumed prior to her illness were too delectable for her to detect danger. It was a sweet treat from Mom who was getting better, *right?* She looked vibrant and youthful but her family retained the image of poor unfortunate souls. She did not know what was wrong with them, but it was evident that there was a reek of garlic on the breath coming from everyone except Mom and Stasia.

Drew began avoiding her food as, like her younger brother, her body became weak and sickly. *But it's just the flu, huh?* One specific day while home sick with her family and Stasia, she lay in bed woozy with the ceiling spinning. Stasia had been sent off into town in search of more cough medicine, while Mom resorted to the confines of the kitchen much like her "normal" self.

1 minute felt like an hour

12 minutes felt like a day

30 minutes felt like a century as she longed for relief.

Drew plucked herself out of bed reluctantly to get water, unable to yell for her mother downstairs or for her equally sick father on the other side of the house. She made her way down the hall where she was able to peek through her brother's cracked door. He lay in his been face up toward the ceiling with an unsettling stillness. His body resembled an embalmed corpse, the image sending shivers down her spine. If it weren't for the tiny heave in breath she saw lifting his chest up and down, she would've sworn the worst days had fallen on the Moore household.

Drew's feet shuffled slowly down the hill of steps as she held on tight to the stair railing. She felt old and decrepit and worried that this strain of flu was something that called for much more concern. Passing the row of lifeless family photos that framed the walls, she noticed how much they reflected the family's current disposition. Behind those rehearsed smiles was a general air of malaise.

She crossed the into the living room and the hall leading away from the foyer and into the open kitchen. Of what she could smell, the aroma in the air was sweet and savory. She watched the back of her mother in another Scheele green summer gown stir a pot of presumed soup. Mom was getting back into the swing of things as everyone else's world had completely detached from the pendulum.

A tiny glass vial with a cork lying beside rested on the counter. There were no remnants of the liquid inside. Drew assumed the contents accompanied the flavor of the soup. Upon smelling the welcoming aroma, the girl felt anything but hungry. She felt a foreboding presence and a strong sense of unwelcome from her mother.

"Drew?" Mom voiced without turning her back to know her daughter was behind her.

"How did you notice it was me?" Drew replied.

"What are you doing out of bed sick? Stasia will bring you medicine soon. I'll be bringing all three of you medicine soon. Go back to bed," she said as her dress remained the only source of vibrancy in the house's now dull interior.

"I just came down for water," Drew strained.

"Go to bed," mom asserted once more. Drew ignored her as her throat cried for relief, shuffling her way to the refrigerator next to her mother who worked on her deadly dish at the stove.

"Mom, can we call a doctor or an ambulance? I really don't feel right," Drew slurred. With that proclamation now proposed, the spoon Mom had in her hand flung into the air and onto the ground. The woman quickly shifted to face her daughter, grabbing her wrist tightly and boring holes into her eyes, frightening Drew immensely.

"Can I not care for you properly? Can I not nurture my sons and daughters? Can I not be a good wife?" barked Mom.

"Mom, you're hurting me!" Drew managed to muster as she uncomfortably tried to pull away. She felt drained and confused and wasn't quite sure what was going on.

The soup continued to violently bubble as mom continued to stare at her. Mom released her wrist and Drew let it dangle beside her, astonished at her mother's actions. A cheeky grin washed over Mom's face as if what had just happened was a laughing matter. Drew began to back out of the kitchen and into the hall before she stumbled on her own foot and hit the cold floor with a thud. As the room began to spin, she could hear her mom's laughter from the kitchen as the woman continued to cook, splashing

unidentifiable spices and liquids in the pot as she went. The laughter rang in Drew's ears as it increased in volume. Drew's eyes began to flutter shut as she lost consciousness. The last thing heard was the sound of her mom's unhinged giggles and the words, "Don't forget to smile, sweetheart!"

19.3 THE REVEAL

Not knowing how much time had passed since her collapse, Drew lay frozen on the living room floor. Shifting her head left and right, she could not detect a soul around. The only thing she could detect was that same overbearing scent of garlic. This time, no sweetness was mixed in the air.

Drew's chest heaved as she struggled to breathe again, feeling as if she was coming in and out of consciousness. She had broken out into a cold sweat that weighed her down.

"Dad! Elliot!" she attempted to scream, but failing to muster up any noise.

Where had Mom gone, and when would Stasia be back?

Looking around was all the girl could do. She looked around to see the tiny feet of her brother descending the steps. As she peered up at his figure, she could see his long johns covered in vomit and a bit of blood. Tears streaming down his face, he collapsed next to his sister as they both lay helpless. A guttural moan came from her brother as the vents filled with more arsenic, unbeknownst to them.

The glaze in their eyes welcomed an end. A tear escaped her eye as Elliot's mouth remained agape, eyes barren. Looking back up at the sky ceiling for one last time, she wasn't sure if she was hallucinating or not. Two tiny hummingbirds flew overhead. One with a wine-stained neck and the other slightly

bigger in stature. They fluttered about the house, looking down at the lifeless children before plummeting out of Drew's sight. The young girl's eyes ceased to move as she lay increasingly cold. That was their last clue.

Her smile absorbs the energy in the room, one that wades in gloom.

20

THE HAPPENING

———

Ann had entered her and Mark's shared master bedroom. He was sound asleep, a bit too comfortable for her liking. She had brought a bowl of soup on a tray for her husband. Setting the tray up around his body and placing the soup on top, she woke him up by pulling his eyelids open with her fingers. Groggily, he shifted his body to look up at the green fabric that enveloped her body.

"Ann, what are you doing? What's all of this?"

"It's soup to help you rest, honey."

"Did you and the kids eat without me?"

"They've been take care of," she said while she shifted her dress.

"That's sweet of you, Ann," remarked Mark. A sharp pain met his side as he let out a grunt of discomfort. "I don't know what type of cold these kids brought home, but it isn't letting up."

Ann smiled at his assertion and waited until he propped himself up to begin eating his soup.

"Doesn't it seem a bit stuffy in here to you? And what is that smell?"

"Eat," she demanded as he struggled to gain control of his body. The spoon in his hand shook with uncertainty as his limbs slowly began to fail him. He lifted the spoon to his mouth, taking one big gulp of the hot soup.

"Sweetheart, I want you to remember me," Ann said, rising off the bed.

"What?" Marked questioned, fighting back a cough.

"I want you to remember me one last way." Ann walked toward the foot of the bed swaying in her sundress and white heels.

Mark took another big gulp of soup from his spoon. He began to choke back more coughs as he patted his chest in irritation.

"Not as your wife. Not as your maid. Not as your child bearer. Not as yours. Remember me as Ann, the woman you'll never forget."

Mark broke out into a coughing fit as he choked on the tampered dish. Ann had concocted a special version of his favorite: wedding soup.

- *Freshly made ground beef meatballs*
- *1 tablespoon of cyanide*
- *1 1/4 cup of diced carrots*
- *1 1/4 cup of diced yellow onion*
- *1 cup of diced celery*
- *a few tablespoons of arsenic*
- *5 cups chicken broth*
- *1 cup dry acini de pepe*
- *6 oz fresh chopped spinach*
- *and finely shredded parmesan to top it off*

She was sure her recipe would be a hit. Mark began to cough up his food and soon blood. His body folded over in agony and moaned in pain. His face hit the soup with a splash and

his body halted its movement. There were no more smiles, no more breath, no more life, no more Mark.

Ann exited her room and descended the stairs, seeing the lifeless bodies of her children lying toppled next to one another. Was this the autonomy she had never known? The silence was soothing. Ann was sure of Stasia's impending return from the store as she had given her precise instruction to get the medicine from a pharmacy far across town, as well as a large bouquet of roses on her husband's dime. Ann had insisted she take the family car as there was no need to run her own empty gas tank in her Volkswagen. Stasia had left her own keys on the kitchen counter after abiding to Ann's requests. Stasia had been gone for a good hour since Ann had begun cooking.

Ann swayed around the house making her way back into the kitchen. On the counter lay a book of recipes she had shared on previous visits with Stasia, which she called *A Cookbook for the Victorians*. It lay on top of her other book *The Principals of Good Taste and Ornament*, which she swore by. If Stasia were to replace her, she might as well claim her identity in good taste. Grabbing a napkin and a pen from her purse, she wrote "For Stasia. Your sister in soul, Ann."

Ann placed the pen and napkin atop the books and exited the kitchen, grabbing her dainty purse, Stasia's car keys and rose charm bracelet. Opening the front door, Ann exited the Moore household for one last time, not looking back at her past one bit. It was the last time she let someone else identify her. Walking down the walkway, she opened the door of her tiny yellow bug and closed it behind her. With a gummy smile and freedom, she put the key in the ignition as her rose pendant dangled against her wrist. Foot to the gas pedal, she drove out of the cul-de-sac, never to be seen again.

I am not evil. I am only human.

As Stasia had pulled into the neighborhood her brow creased at the sight of her tiny yellow Volkswagen passing by with a glowing Ann in it. The woman gave a smile and slight wave as she pulled out of the subdivision and sped away. Stasia promptly stopped her car in the middle of the street, attempting piece together where Ann was going with her car despite her request to bring medicine and roses to her family just an hour before.

Had I taken too long? She thought. A heavy honk from the car behind her prompted Stasia to snap out of her trance and keep on down the road to 40 Walnut Drive. It was strange to see Ann out and about with her car, but maybe an explanation would provide itself inside the Moore house. *She couldn't have gone far.*

Stasia pulled the family car into the Moore driveway and opened the garage. Upon doing so, a waft of light grey smoke enveloped the air. Mark's car had been running the entire time she was gone. A faint beeping sound from inside the home had begun to sound loudly. Leaving the engine on, Stasia quickly hopped out of the car, door ajar. She ran to the front door in such a hurry she heard a distinct "clack" of her dingy homey sandals breaking, causing her to slip and slightly scrap her knee. Palms on the ground, the frantic young woman lifted herself up and examined her wound as her finger swept across her now wet knee that oozed blood.

She had no choice but to limp forward as her hand grasped for the front door that opened with ease. It hadn't even been locked. As the door was pushed open, another small waft of air punched Stasia's face making her cough frantically. The young woman took a step inside the home into the foyer.

"Dr. Moore?" she hollered through the foggy residence. "Elliot? Drew?" She continued hesitantly, walking down the hall and into the kitchen. Quickly, she hustled to the stove where flames shot out beneath a bubbling pot of wedding soup. It reeked of garlic, the smell making her increasingly woozy. The girl worriedly began to search for the occupants of the home as she swiftly ran past the note and books that Ann had left for her. The napkin flew in the air as her gust of wind knocked it off the counter.

"Elliot! Drew!" she yelled, running back into the hall where she stopped and fell to her knees. Her legs buckled under her at the sight of the two perished children. They varnished a sickly tint that made Stasia ill. Their eyes had glossed over like shiny marbles that made her direct her attention elsewhere.

"Dr. Moore!" She wept between cries, picking herself up, and walking up the stairs. She could see from down the second floor hallway that the doors to the master suite had been blocked by furniture to prevent an escape. Her heart sank to her toes. Carefully, she placed the chairs and framed family photos blocking her way to the side as she was afraid of the image that would be juxtaposed with those performative smiling faces.

The door flew open with a push of her hand. She saw the face of Mr. Moore drowned in wedding soup.

Her eyes rose to the window that let in a small ray of light. As she peered out, she could see a hummingbird fluttering across the sky. It was odd to see one this time of year, but it looked at her with a sureness that she lacked.

The sirens of fire trucks sounded as Stasia stood staring at the tiny fluttering bird looking back at her. As she inhaled the toxicity in the air, her mind became engulfed in

confusion. The sirens whined as the evening sun began to peek out beneath the clouds. She felt the warmth on her face.

The first authentic feeling of warmth she felt with the Moores was when they were no longer there at all.